Whole Terrain
REFLECTIVE ENVIRONMENTAL PRACTICE

About Time
Volume 24

CONTENTS

ANTIOCH UNIVERSITY
NEW ENGLAND

Editor's Note
Cherice Bock

We are stardust
We are golden
And we've got to get ourselves
Back to the garden

Then can I walk beside you
I have come here to lose the smog
And I feel to be a cog in something turning
Well maybe it is just the time of year
Or maybe it's the time of man
I don't know who I am
But you know life is for learning

—Joni Mitchell, "Woodstock," 1970

When we selected the theme About Time for this volume, we considered the double meaning of the term. We were looking for pieces related to the concept of time, and this theme assumes it is "about time" to respond to the urgent crisis of anthropogenic climate change, species loss, pollution, and subsequent environmental injustices experienced by people and other beings with whom we share this planet. These themes of the passage of time and the urgency of this moment are interwoven, as you will see in this volume's contents.

We also chose this theme because of the volume number: 24. Most people alive today divide our days into 24 hours. Humanity could have chosen to understand the passage of time differently, but the tradition of 24 segments goes back to at least ancient Egypt. The Egyptians divided up the hours of the night based on the rising of 12 stars, and divided up the day into equal parts, 10 hours for daylight and an hour for dawn and twilight on either side. The length of each "hour" depended on the time of year with one-tenth of each day lengthening as the planet tipped toward the summer solstice. As the length of each hour became standardized for scientific purposes, and for consistency as human beings learned to communicate and travel across long distances, the day was divided into 24 equal hours, each with 60 minutes comprised of 60 seconds—but of course, this is inexact, as each day is really more like 23 hours, 56 minutes, and 4 seconds, not to mention the variations in the length of each day due to the Earth's distance from the Sun, the speed the planet is traveling, and slight differences in planetary orbit across time.

We also separate the planet into 24 slices indicating time zones, but of course time is experienced differently at one side of the time zone than at the other. Some of the boundaries of time zones are not defined by science or math but are instead based on political boundaries or population centers. (For example, though China spans five regions otherwise considered different time zones, it observes the same time across the entire country; likewise, time zones

in the United States bend to include or exclude population centers such as the metro area of Chicago.) While humanity has attempted to systematize time based on place and mathematical reasoning, we cannot alter the flow of time; instead, we must adapt to its ongoing flow.

One can see the connections between the human desire to control time and our destruction of planetary systems: as a species, we desire to live longer, to have access to our favorite foods regardless of where we live or what season it is. At times we stimulate ourselves and use artificial light so we can pack as much as possible into each waking period, and at other times we numb ourselves so we do not have to feel the crushing weight of the relentless march of time, seemingly devoid of meaning. Our desire to control and standardize the world around us has led to the destruction of habitats and ecosystems as we try to have every resource available in every place at every time, negating the cycle of seasons and the distinctive features of each place. Our assumptions about the length of time to travel between places and the time it takes to complete tasks has changed as we have burned fossil fuels for transportation, resources accrued over millions of years. Our sense of the amount of time an item is useful has been altered; we use "disposable," fossil fuel–based plastics once, and they live on much longer than we do, continuing to harm ecosystems. As byproducts of stolen time build up in Earth's atmosphere we have less and less time to change course before triggering planetary changes that will cause mass extinction—or perhaps we are out of time already. Many continue to trust our human ability to problem solve to get us out of danger in the nick of time through innovative technologies and efficiencies.

The contributors to this volume take a different approach, acknowledging that time and place are inextricably bound up together, connecting us to the soil to which we will return. Urgency to act sits side by side with deep grief for what is being lost as contributors savor the fleeting beauty of scenes that may never be seen again. **Kathleen Dean Moore** marks the passage of time in "The Tadpole Madrigal" by writing the time of day at the opening of each section of her essay, and she also marks the seasons, years, and epochs as she pays close attention to one small pond as it moves through the day and through her memory. She poignantly reflects on the swallows returning too early one year and starving to death, with winter conditions slowing the spring insect hatch, a theme picked up in "Missed Rendezvous" by **Amy E. Boyd**. Boyd's essay explores and explains what happens when planetary cycles send signals disrupting species' timing in a given place. Images from the Galápagos Islands by **Sheri Vandermolen** remind us of species being lost due to human impact, as well as the almost unfathomable length of time it took each species to evolve, invoked through an image of the tortoise species made famous by Charles Darwin. **Johanna Spaeder** depicts one place in each season, a rhythm of time in harmony with place, a species creating a home for itself and others.

Each piece in About Time contains the fear and beauty of impermanence alongside the awe-inspiring nature and dreadfulness of our small moment in the expanse of time. Traces of time experienced in a particular place find meaning in **Jeremy Elliott**'s "Artifacts" as he explores the clues left by previous human occupants of his home, looking back a few years, a few generations, or hundreds or thousands of years, and as he deciphers the stories told by the landforms and fossil records that offer a glimpse into geological time. **Leath Tonino** reflects on his developing awareness of time in "A Little Boy's Whale," discovering the secret of whale bones buried inland, his imagination expanding in joyful awe at the expanse of time's interaction with place. The perfect beauty and reminder of death encapsulated in snow drifted seed husks draws the attention of **Heidi Watts** in her poem, "Winter Weeds." **Sean Prentiss** meditates on the

inevitability of an endpoint, of falling apart, of days and days passing until there are no more in his poem, "Entropy." The brevity of human life is made visible by studying individuals whose lifespans dwarf our own, such as the ancient trees depicted in the lithographs "Sonora Pass Cedar" and "Fudo, the Bristlecone Pine" by **Davis Te Selle**. In the brokenness and beauty of Crater Lake, **Liz N. Clift** explores in her poem, "13 Letters to Crater Lake," her relationship to the place, herself, and others across time, remembering back through the layers of Crater Lake's and her own volcanic history to find healing, new growth, and identity.

As a species of storytellers, humanity has told ourselves stories for as long as we know, making sense of time through meaning and connection. **John Hanson Mitchell** weaves together myths and data, mysticism and science in "Legends of the Common Stream," drawing us again toward knowing the world through storied interconnection. In the present moment, some of our stories need to sound the alarm: all is not right, our planetary impact is already harming people and may spell the demise of our species. In "Reflections on Houston in a Time of Crisis," **Samantha Harvey** tells such a story of intersecting and compounding injustices harming vulnerable people, from environmental toxins to air pollution to hurricanes. **Randall Amster** pens a cautionary cli-fi tale in "Remembering the *Terrapods*," imagining an alien anthropologist analyzing the remnants of our dead civilization to understand the beautiful and terrible story of our collective self-destruction. **Kimberly Langmaid** documents and grieves steps toward this currently fictional end in her essay, "Crossing Thresholds in Yellowstone," as she visits a standing dead forest that has succumbed to bark beetles and fungus no longer limited by cold winters.

John Bates and **David Solomon** seek to reframe stories we have told ourselves in the United States in their essays, "What Hath God Rot?" and "One Generation's Treasure." Each considers the different understandings of previous generations regarding what is considered a beneficial species and how to manage resources. Bates recognizes a time and a place for rot in a decomposing forest that creates the literal ground for its own rejuvenation and articulates a different understanding of waste compared to the assumptions of previous European Americans. He notes that weeds were not considered so by those who brought them here, and this idea is further developed in Solomon's essay as he describes seasons spent removing invasive species from natural spaces, species brought here intentionally by immigrants from other continents. The question of whether the problem is too big to keep hoping is overt or underlying many of these pieces, and the contributors shape stories of meaning so that they—and we as readers—have the courage and motivation to keep going.

Finally, in "Cultivating Patience," **Rebecca L. Vidra** discusses human attempts at restoring natural spaces: are they nature? Can we ever heal that which we have disrupted and destroyed? Perhaps not, and the scars of human intervention will outlast those who attempt to set things right, but the natural world has a profound ability to heal itself, and us. There is yet hope, but it is a slow and methodical hope, living and generative, not something that can be remade through a quick fix or reset to factory settings with the push of a button. Instead, About Time contributors imply, this hope requires careful attention to a particular place. It involves developing an intimate relationship of love and longing, grief and awe, humility and courage as we locate ourselves within time. It requires telling ourselves a new story that is as old as the hills, a story of beauty and death, a story in which it is urgently time to act for the sake of life on this planet, while simultaneously we are specks of stardust afloat on a vast expanse of space and time.

Cherice Bock *(she/her), the coordinating editor of* Whole Terrain's *About Time volume, lives with her family in Oregon on the traditional lands of the Kalapuya. While finishing up her doctorate in environmental studies from Antioch University New England, Bock uses her master of divinity and master of science in environmental studies to teach college and seminary courses relating to religion and environmental justice. She does faith-based organizing and advocacy as the leader of Oregon Interfaith Power and Light. Bock co-edited and contributed to the book* Quakers, Creation Care, and Sustainability *(2019) and has published several articles and book chapters at the intersection of religion and environmental concerns.*

The Tadpole Madrigal

Kathleen Dean Moore

11:30 AM. As I study the pattern of rain on the pond, the surface breaks open and a hooded merganser pops out. As soon as my binoculars bring her into focus, she shrugs—hup!—and dives. I presume she is winging around down there, slurping up tadpoles. It is early April, and the pond is thick with them, black dots with frantically wriggling tails.

Until the squall moved in, I watched violet-green swallows swing over the water, snatching mayflies or midges or mosquitos. I don't know exactly which. They all look like glitter, ascending. I can understand how a swallow could catch a crane fly as it slouches along with dangling legs. But the timing required to snatch a single gnat from a cloud of gnats? That's beyond me.

And here's an even greater mystery of timing: How does the swallow, fattening up over salt marshes in Mexico, decide that she must leave exactly that day, if she's going to arrive at the pond in Oregon just as the insects are emerging? And how does she pull off that miracle of foresight, to lay her eggs so they will hatch just when the caddisflies are crawling up cattails into the light? To a swallow, timing is everything.

Scientists are quite sure that the swallow's restlessness is triggered by the length of the day, and that the insect emergence is triggered by the temperature. But those same scientists have little to say about whose waving hands mark time in this planetary madrigal, cuing light, then cuing warmth, now the migrating ducks, now the greening weeds, the budding trees, the returning rains, the tadpoles and the gnats, the squalls blowing in from the sea. Of course, there are always stutters and starvation. But generally, the timing has been close enough, and the animals evolved in the dependable rhythms of this world, living and dying to the drumbeat and the hum.

The Earth still slowly spins; the cycling days remain steadfast. But weather now comes and goes with violent, wild variations, and we all struggle to make sense of it. It used to be that no one blamed the weather, because we knew it had no will, no viciousness or injustice. But the weather has lost its innocence. The hand that now conducts the swirling chorus of air and water is the human hand of oil and gas industry giants, flinging greenhouse gases into the air, altering the currents of wind and water, disrupting the rhythms in the ancient symphonies of small lives.

Last year, the swallows got the timing wrong. They came back to Oregon before winter was finished, and there were no insects in the wind. I have seen a starved swallow, its wing frozen to the sand. I have seen the frozen eye of a swallow. It's white. You can't see into it.

This year, I found a dead bat in the corner of my cabin, where a slat had fallen loose. He was a tiny thing. His black wings were extended, his face locked in a bat's toothy grin. I was sorry to see it dead; I worried that the solar gain through my window had tricked the bat into waking early, into thinking it was spring when it was still winter, and it starved. To a bat too, timing is everything. Now midges spin in small cyclones over the pond and mayflies rise from bent reeds. But in the air rising from the pond tonight, there will be no little bat with moonlight in its wings.

1:30 PM. I'm startled to see a turkey flush out of the fescue, flapping madly. He has no

sooner scrabbled onto a pine branch than a coyote trots onto the dike. The merganser runs across the water and arrows off to the northeast. I rush onto the porch with binoculars. None of this fuss alters the coyote's pace: one step, a pause to look behind, another step. Wind riffles the water and lifts the coyote's tawny fur.

The only denizen of the pond who is sitting still in all this ruckus is Frank. In a folding chair under a black umbrella, he leans toward the water, wearing headphones, holding a recorder in one hand and a bagel in the other. He wants to record a red-legged frog, a rare frog that burbles underwater. But it may be too late in the season or too early in the day. The only frogs singing now are Pacific tree frogs, the tiny green ones, but their hearts aren't in it. Most of them have already mated and laid their eggs.

The warm rains of the waning winter drew the tree frogs into the pond, and then the yelling was so deafening that the neighbors complained about the noise. That's when we

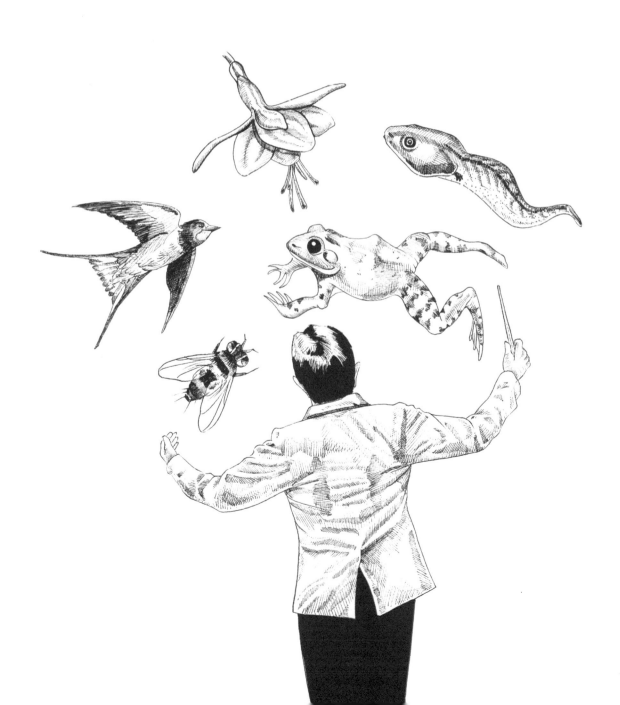

brought our two little grandsons out to the cabin—to probe the darkness with flashlights, to fill their boots with pond water, in every pond-side hole to find tiny gold eyes staring at them in reciprocal astonishment. To fall asleep to the frogs' lullaby, but in fact not falling asleep until a blanket of cold quieted the frogs. The boys were out the door first thing the next morning, their yellow raincoats bright against gray wind-wrinkles on the pond. "I found a newt," one shouted, and two damp heads bent low to the water. "Nonni, come see," and of course I did.

It's been much cooler since then, which has my husband worried. After the first warm rains and that orgy of singing, the weather has turned cold. Nasty cold. Now in April, it is long past time for the rainbow showers of spring to arrive. But still we have the dead-earnest rain of winter. Incessant rain loosened the roots of the big Douglas fir across the pond, and in one last gust, it toppled, all 100 years of it, all 150 feet and an owl's nest. The cold is going to slow the frogs down, and who knows how quickly summer will come.

Our pond is a seasonal pond, which means that every summer it dries to a shallow scoop of hardened mud and a lattice of dried pondweed. This means that the frog eggs are in a race against time from the moment they are laid. As the pond begins to sink into its muddy bottom, the tadpoles grow outsized hind legs and little *T. rex*–like forearms. Then they resorb their tails and—if they get the timing right—crawl out of the pond just before it vanishes. Larval newts, no bigger than crickets, with lacy gills and legs thin as threads, hang near the bottom, seemingly bored. But they too are in a desperate race to resorb their gills and grow big enough to crawl out of the pond before it dries. They too must become creatures of the damp land before summer comes, plodding through the last of the rainy days into the forest and the river.

Every year, the question is, *Will the pond creatures mature fast enough to escape the pond before summer's drought?* This depends on the weather, and it cuts both ways. The warmer the weather, the faster the eggs develop into tadpoles and the faster the tadpoles develop into frogs. But it's also true that the warmer the weather, the faster the pond shrinks. The froglets crowd into smaller and smaller spaces, wriggling now with their backs out of water. They might not know that the pond is shrinking, but they can sense they're getting crowded. Perception of density triggers even faster, now frantic, rates of growth—if there is enough to eat. Frank says that one amphibian, the spadefoot toad, grows a tooth when the pond gets too crowded. Then he transmogrifies into a cannibal, stabbing that awful tooth into his sisters.

∽

3:05 PM. The squall has blown over and the swallows are back, chasing flecks of sunlight. Last year, summer came early, the sun hot for weeks on end. As the water level sank, the pond became a minestrone of little wriggling things, not yet terrestrial creatures, not quite yet. We checked every day, despairing.

Too soon, the pond was reduced to a skim of algae-choked water shimmering with lives. The sun rose hard and white every morning, sank hard and red every evening. The pond shone like gold-plate, wrinkled by the struggling animals. The water warmed to the temperature of urine.

We gathered nets and buckets. With the children, we shuffled through the hot water, scooping up small lives, lowering them into buckets and carrying them to the river. And then again. So many hopeless tadpoles, so many newts, impossibly delicate. They were so concentrated in the shrinking pond that none of us could walk without crushing soft bodies into the mud. The little boys were horrified, paralyzed in place, waving their nets and

calling for help so they could walk without killing. But we couldn't help them without ourselves crushing the tadpoles. We did our best. Bucket after bucket of quivering black things we poured into the river, and how did they survive that plunge? The boys stood ankle-deep in warm water, socks sagging around their ankles, and stared into the buckets at the tadpoles.

"Hurry," they called out. "They're dying." But when the number of crushed animals was greater than the number of animals that remained, we gave up. There was no saving them.

We found a place to sit in the shade and rinsed the mud and corpses off our sneakers. The boys lay on their backs with their arms over their eyes. "I think we saved enough just in time, do you think we saved enough, yes?" the littlest one said. "Maybe or maybe not," answered his brother. The question on my mind was even more sorrowful. Have we run out of time to save ourselves? Distracted or complacent, have we missed our cues, the melting ice caps and rising seas, rising lines on scientific charts, mounting voices of urgency or denial? Maybe or maybe not. Time is not on our side.

Two days after our rescue attempt, the water was gone from the pond, and the mud was painted with a black layer, like melted tar. That tarry layer was the bodies of frogs and newts who lost the race against the uncaring heat. By the next week, the tar had cracked and curled at the edges, and who could imagine that such a dark thing could ever have filled the evening air with song?

∾

Kathleen Dean Moore is a writer, moral philosopher, and environmental thought-leader devoted to the defense of the lovely, reeling world. As a writer, Moore first came to public attention with award-winning books of essays that celebrate and explore the wet, wild world of rivers, islands, and tidal shores such as Riverwalking *and* Holdfast. *Her first climate ethics book,* Moral Ground: Ethical Action for a Planet in Peril *(co-edited with Michael P. Nelson, foreword by Desmond Tutu) gathered testimony from the world's moral leaders about humanity's obligation to the future. In 2016, Moore published* Great Tide Rising: Finding Clarity and Moral Courage in a Time of Planetary Change, *and a novel,* Piano Tide. *Moore's essays are widely published in magazines such as* High Country News, Orion Magazine, Discover, Audubon, Utne Reader, Earth Island Journal, New York Times Magazine, *and* Conservation Biology. *In 2021 Moore published two new books,* Bearing Witness: The Human Rights Case Against Fracking and Climate Change, *and* Earth's Wild Music, *from which this essay is excerpted. Kathleen holds a PhD from the University of Colorado and she taught at Oregon State University.*

Missed Rendezvous

Amy E. Boyd

Imagine that you are meeting the love of your life, at a mutually established time and place, from which you will start your new life together. But when you get there, your love does not show up. You wait, and no arrival. Eventually you give up and move on, missing your chance for happiness. It turns out your love did come, and to the right place, but you missed each other because your love was assuming a completely different time zone and arrived several hours late.

Now imagine that this is the case for everyone in your species: a world full of connections missed—possibilities for eternal happiness lost across the board because timing was off.

This is a very loose analogy for one of the biggest ecological problems stemming from the climate change that our planet is facing today. Interactions between species can be beneficial—and are indeed necessary—for one or both species, and these interactions have evolved over thousands or hundreds of thousands of years. Flowering plants may depend on pollinators for their reproduction. Herbivores may depend on the timely emergence of plants to support their metabolic needs, just as predators depend on the timely development and emergence of their prey that in turn depend on the presence of their own food sources. Parasites must develop at the right time to infect their host, and, in many parasites, this involves different hosts at different parts of their life cycle, all of which must be timed appropriately.

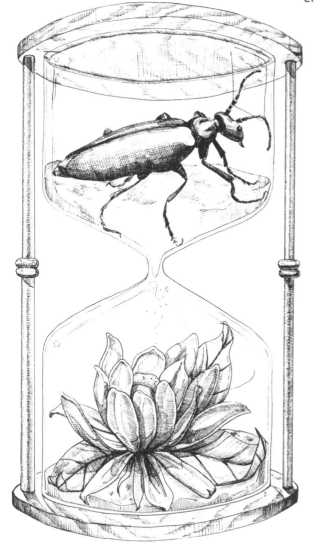

Scientists refer to the timing of biological events within a year as "phenology." Phenology is the study of the calendar of nature: the study of when the roses bloom, when leaves change color in the fall, when frogs begin to sing their mating calls, and when songbirds build their nests. As humans, phenology dictates when we should plant seeds, when we prepare for allergy season, and when we harvest to avoid frost.

Phenological timing usually involves the organism responding to some kind of environmental cue, such as day length or daily maximum temperature, that tells them when the time is right. Birds in North America that migrate to their breeding grounds in the spring mostly use the amount of available sunlight as their cue, beginning their northern movements when the days reach a

certain length. Wood frogs, on the other hand, start singing their mating calls and laying eggs after temperatures and precipitation have reached a certain threshold for a number of days in a row.

Phenological studies have received increasing attention in recent years. What once seemed like a relatively static process, albeit with variations from year to year, is now known to be a key feature of ecological response to climate change. As spring arrives earlier, plants may respond by flowering earlier to beat the summer heat. Perennials may emerge from the ground earlier and develop defensive chemicals earlier, turning their vegetation from palatable to distasteful to protect their developing organs from herbivory sooner than happened in the past. Butterfly eggs may respond to earlier warmth by hatching earlier, developing into larvae earlier and possibly more quickly. Wood frogs may sing their mating calls earlier in the winter and may lay their eggs earlier, resulting in earlier maturation of the tadpoles into adults.

If all organisms responded in exactly the same way and at the same rate, although the bigger picture would change, the relationships would still be successful. Pollinators would find the flowers awaiting them; birds would find the caterpillars that meet their nutritional needs during breeding season; parasites would find their hosts at the right time for their next stage of development.

But here's the catch: as mentioned above, not all organisms respond to the same seasonal cues. One species might respond to average daily temperature as its developmental cue, while another responds to nightly low temperature, and another responds to day length. These can lead to very different responses. The seasonal shift of day length is consistent from year to year, while average daily temperatures have always been variable between years and are more unpredictable now due to climate change. In addition, even if ecological partners do respond to the same cues, they may not respond to the same degree or at the same rate. If two species that depend on one another, such as a plant and its pollinator, respond to different seasonal cues, and one or more of those cues are changing over time, they may end up completely missing each other, resulting in what ecologists call a phenological mismatch. In particularly critical cases, this could lead to decline of species or even complete reproductive failure.

Over the past twelve years, I have been studying pollination biology in a native shrub, *Calycanthus floridus*, that has an unusual combination of floral characteristics: wine red–colored flowers, petals that form a small chamber around the reproductive parts, and, most unusually, a scent that can be sweet and spicy or resemble overripe rotting fruit, depending on the stage of the flower. These characteristics turn out to be just right for attracting a small brown beetle. The beetles appear when the flowers open, crawl inside, sometimes in great numbers, and hang out in the flowers for hours, feeding on the pollen and even on the flower parts. In the process, they fertilize the flower so it can produce fruit and seeds. This plant family is quite old. Its lineage is near the base of flowering plant evolutionary history, and presumably its relationship with the beetles has been evolving for a very long time as well. (Beetle pollination is one of the oldest forms of animal-mediated pollination, present in some plants even before flowers evolved.)

As we have watched our study population over the years, what we see is that although in some years the beetles show up in great numbers, pouring out of the flowers like clowns out of a circus car when you pry the petals open, in other years they are completely absent. The flowers open, bloom beautifully, pour their pungent scent out into the spring air, but the beetles are nowhere to be seen. Some years, not a single beetle is seen in the flowers, and these years

appear to be years when spring comes unusually early, the climate turning unseasonably warm weeks before the historic norm. And, as we know from climate scientists, these early springs are becoming more and more common.

Will *Calycanthus* someday bloom so consistently early that they never see the beetles that serve as their reproductive conduits? And, if so, will they cease to be sexual beings? We know from breeding experiments that the plants need pollen to be carried between flowers for seeds to set; the flowers cannot successfully pollinate themselves. We also know that reproductive success—production of fruits and flowers—is extremely variable from year to year and generally quite low. It would not take much for this plant to go from being a sexually reproducing species to one that reproduces solely using underground rhizomes, producing flowers for no purpose. If the beetles never arrive, the flowers could be a beautiful waste of resources for the plant, as there are no other effective pollinators, and this may also impact the life cycle of the beetles.

These phenological mismatches are being documented all over the world in a wide variety of habitats and species interactions. Plant-pollinator interactions are the source of many of the clearest examples. For example, scientists at the Rocky Mountain Biological Laboratory in Colorado have conducted manipulative experiments with a little spring wildflower, lanceleaf spring beauty (*Claytonia lanceolata*), to determine how changes in flowering phenology might affect their reproductive capacity. The scientists artificially altered flowering phenology in two ways: by manipulating snowpack in the field, and by inducing different flowering times in a greenhouse. They found that when flowers bloomed earlier, they were more likely to be successfully pollinated but were also more susceptible to frost damage, so they faced tradeoffs in their timing. Simulation studies have shown it is likely that 17–50% of pollinators will suffer from disruption of their food supply due to temporal mismatches in the face of unchecked climate change.

Predator-prey relationships are also showing evidence of the impact of phenological mismatch. Biologists who examined 37 years of data on great tits in the Netherlands found that, in some years, timing of the birds' breeding does not correspond well to the timing of peak caterpillar season, although caterpillars are the great tit's primary food source during reproductive season. When this mismatch occurred, it impacted the birds' reproductive success in number of broods produced, fledgling success, and other factors. In a study focused on caribou in Greenland, where these large herbivores prolong their intake of young, digestible, and nutrient-rich plants by selectively foraging across landscapes, biologists found that when plots were artificially warmed to simulate climate warming, the phenology in the plants on which the caribou depended became less variable across the landscape. What this means is that, in a situation where the caribou depend on plants emerging and maturing at various times across space to provide for them through the season, global warming could shrink this variability and, in doing so, reduce food availability for the large mammals.

Lemmings are known for their boom-and-bust population cycles, reaching mind-bogglingly high numbers in some years and then dropping to near extinction in others. In tundra ecosystems, lemmings are a keystone species, providing food for a diversity of predator species that have adapted to the lemmings' wildly fluctuating population cycles. However, like many arctic and alpine species, they appear to be highly sensitive to climate change; their population dynamics are primarily dictated by snow conditions, which are changing due to global warming. At some sites, the previously regular population cycles of the lemmings have been disrupted since the turn of the millennium, resulting in perennially low population sizes, and studies of

long-term community monitoring data show that this is having a negative impact on a diversity of predator populations from snowy owls to arctic foxes.

As we face a future on an increasingly warming planet, we will see a myriad of effects on all kinds of organisms. Polar bears have become a hallmark of these concerns as they lose the sea ice habitat they depend on for hunting prey, such as seals, and for finding dens for their cubs. But interactions between species are also at risk, and as climate change impacts timing of species' cycles, these interactions may become disrupted, threatening one or both members of the interaction. As a result, our world is likely to see an increasing incidence of missed rendezvous in the natural world, with interacting species missing each other because of bad timing.

Amy E. Boyd *is professor of biology and chair of the Division of Natural Sciences at Warren Wilson College in Asheville, North Carolina. She is an ecologist and evolutionary biologist whose research currently focuses on plant-pollinator interactions and phenological patterns.*

Winter Weeds
Heidi Watts

"We should take some home," he said.
The crop of winter weeds grew upright
In the white fresh-fallen snow
Yellow like straw, like sand, like sunlight
It was the sweet surprise of them,
Suddenly—there beside the ski trail:
Dried sprays, seed rattles, bowing
Before the chilling winter wind.

We should take some home?
To blossom in a bottle
On the cluttered kitchen table
In the comfortable confusion
Of opened and unopened envelopes
Of morning tea cups, sugar bowl,
One dirty mitten, pencils, spoons
And the last of the poinsettia?
No.

Better to leave them bending here
To leave evocation to the mind's eye
To know
There is no time but this present.

Heidi Watts, PhD, is professor emerita at Antioch University New England, formerly co-chair of the Department of Education as well as adjunct faculty in the doctoral program in environmental studies. She follows a migratory pattern, living in Nova Scotia in the summer, New Hampshire in the fall and spring, and India in the winter, where she works with teachers in the international community of Auroville.

A Little Boy's Whale

Leath Tonino

Two hundred miles and two mountain ranges from the nearest ocean, I discovered a whale. Well, the bones of a whale. And no, I wasn't the first person to glimpse this unearthed evidence of a marine past; heck, I was only in kindergarten at the time. To be clear, what I discovered was the story of discovery, and then, after the teacher finished her spiel, the actual bones that railroad workers had found in a farmer's meadow back in 1849.

This was during a field trip to the University of Vermont's Perkins Museum of Geology. The whale—a beluga—was from my hometown of Charlotte. Near the train tracks. There in the brambles. So close.

Picture the little fellow I once was, my grass-stained jeans and total confusion. Whale? In the brambles? So close? But how? I knew from visiting my grandparents in Connecticut and my other grandparents in Florida that proper salty habitat was nowhere nearby. Thought the five-year-old me: Vermont equals landlocked, equals no starfish, no bodysurfing, no beachcombing, no pelicans, and most definitely equals no whales. Yet look at these bones, at this beak, at this . . . beluga?

Thus was my awareness welcomed into the wonders of ice ages, fluctuating seashores, and oceans where no oceans exist.

The Charlotte Whale (Vermont's official state fossil) proved to be a huge find for the scientists of the nineteenth century. Darwin's work was not yet published, and the big debate of the era was between glaciers and Noah's Flood. How did the surface of the planet form? Those dirty, disheveled bones offered an answer.

Some 12,000 years ago, glacial fingers pushed south from the Arctic, depressing the land with their incredible bulk. Reaching New Jersey, they turned around, giant slugs crawling north and east, leaving a broad valley in their wake. For a moment, the valley was barren, scoured and dead; then the North Atlantic entered through the glacier's gouged path (the present-day St. Lawrence Seaway) and trickled down to fill the valley's low emptiness, forming the Champlain Sea. Riding that trickle were whales.

Alas, nothing lasts forever. Free from the weight of ice sheets, the seabed began to rise (the technical term is "post-glacial rebound"), forcing the water back toward the ocean. Islands became mere hills amid a vegetated basin, at the center of which rested a thin puddle: a rain-fed lake. Goodbye Champlain Sea—hello bones in mud.

Picture the grass-stained me telling his parents this epic story, telling them all about that day's field trip, all about the discovery of a beluga skeleton, all about the ocean right there in the landlocked backyard. Picture my exuberance, my mind lit with the epiphany of geologic time, of landscapes coming and going, going and coming, shifting, morphing, flowing. Picture, if you can, my realization that even though Connecticut and Florida were nowhere near, I, too, was growing up on the salty edge.

What does it mean to welcome into ourselves, especially at a young age, the monumental fact of birthing and dying seas? I suppose it means lots of things. In my case, it means that decades after that field trip to the Perkins Museum of Geology, hiking some lofty mountain range in the parched desert of Nevada or Utah or Arizona, I stumble on perfect fossilized shells way up there in blue sky, the stumble seamlessly transforming into a silly gleeful dance. This upthrust earth

once was, to quote Ringo, an octopus's garden! It means it once was something other than that, and something other than what it was before that! On and on! And on! Ad infinitum!

The joy of ancient seas, the way they still, today, flood awareness, carrying with them creatures that swim through time and place and mind, through the meeting of the three, this is for me the joy of change. This is for me the joy of a planet that is relentlessly dynamic. This is for me the joy we feel, we discover, when we are young, if we are lucky. It's a joy that's waiting for us near the train tracks. There in the brambles. So close.

Leath Tonino is the author of two essay collections about the outdoors, both published by Trinity University Press: The Animal One Thousand Miles Long *and* The West Will Swallow You. *A freelance writer, his poetry and prose appear regularly in* Orion Magazine, The Sun, Outside, *and a dozen other magazines.*

Artifacts

Jeremy Elliott

How can you begin to understand something like land? One week before our oldest child was born, my wife and I closed on a piece of property: twenty-eight acres on the northern edge of the Callahan Divide, itself the northernmost bump of the Edwards Plateau, the limestone sheet under much of west-central Texas. There's a temptation, especially once you've bought land, once you've made promises involving banks, to see it as an extension of yourself—that your moment with the land, your use of the land, is inherent or just. Like in the creation of any other narrative, other possible branches in the story are trimmed away, and we're left with the idea that the current situation is simply the only potential outcome.

I stood one time at an ancient rock art site in central Texas, talking with a Yaqui religious leader. He pointed at a red handprint on the wall, pressed up by someone millennia ago, and told me that a handprint like that meant "the here and now," a mark of presence. But looking down the wall, there were an awful lot of "here and nows," a lot of hands pressed against, a lot of present moments.

The place we bought was someone else's unfinished project. The previous owner had intended to put up a building on the property and had gone only so far as to pour a massive concrete slab and frame it in steel, so clearly an unfinished dream. I felt like a hermit crab, crawling into someone else's shell. Someone else thought their use seemed inherent and unavoidable as well.

I never feel like I belong somewhere until I've got some deeper historical sense of the place, until I start to know how else the place has existed, some range of potentials and actualities the place has held to others. It's like I've walked into a room with an intense conversation going. Until I've gathered some idea of what's been said, I can't really feel at home. I want to know my neighbors, spatial and temporal. In the years since I moved here, I've gotten to know some of them, caught bits of their conversation through the things I've found. Artifacts: shell fossils, points, a bit of pottery, old horse tack, a rusted spoon. I keep a bowl of them in the house, incarnate memories, reminders of becoming at home here, pieces of the conversation.

Shells and Geology

I had a terrible idea that I wanted to raise goats. The standard joke here is that once you've finished a fence, you should blow smoke through it. If any gets through, the fence won't hold a goat. So, against all reason, I began the process of clearing fence lines. Thick in the cedar one day, with the chainsaw at an idle, I saw a fossil shell on the ground, which is not fundamentally surprising—that's broadly speaking how limestone is formed: years and years of shells and corals and algaes calcifying together, but this one was larger than most, so I carried it back with me that evening. I thought, initially, that it was an Atlantic cockle, just because it reminded me of ones I'd seen on the East Coast, growing up. A bit of internet research assured me that it wasn't, if for no other reason than the fossil predates the existence of the Atlantic.

Deliberate looking for fossils revealed scores more, all marine. I guess I knew through some generic sense of geological history that this area was once submerged. What's now the Gulf of Mexico once extended up to the eastern edge of the Rockies, right? This idea, in the general sense, is comprehensible. To contemplate, though, that the shell fossils I find are

at least 60 million years old, and have more or less been in the same place the entire time, is incomprehensible. It's like how Kant describes what he calls the mathematical sublime— something too vast to contemplate. I understand the abstraction that the Western Interior Seaway split the continent, but I understand much less the specificity that my house is literally on an old reef from said sea, despite the incontrovertible evidence in my hand.

While the seas receded, the mesas surrounding us would have peeked out from the waters for a time. The plains slope upwards in a general sense toward the north, and the altitude of the mesas isn't met by the plains for some 150 miles north of here. Thus, our ridge would have been a chain of islands well off the coast of the retreating sea.

I practice seeing it like that. Imagining the slopes of the mesas as beaches, topographies shaped by waves. Low fogs early in the morning make it easy. The sandy soil of the mesas is suddenly comprehensible when contrasted with the relative loam of the plains. What swam these seas? What was the first creature to walk these islands? What first seed sprouted here?

Trees

There's an obvious difference in trees and soil as you approach the mesas from the plains, even to a non-specialist like me. The comparatively heavy soil and mesquite trees give way, first to the oaks and sand of the slopes and finally to the Ashe and Pinchot junipers of the limestone tops. Walking with a plant biologist up here is an education in my own ignorance. I recognize the trees as oaks, broadly, but the diversity he sees in them is wonderful. These trees are almost living fossils.

Plants migrate, of course. Not as individuals, obviously, and they'll probably take a long time to cover significant ground. Moreover, they generally can't cross a habitat that's inhospitable to them unless aided by some significant outside force. How, then, do these oaks thrive here? What force could have brought them across the plains? And for that matter, how do the bigleaf maple and escarpment cherry exist further south in the Edwards Plateau, or how do lodgepole pines exist nearly as far south as the Mexican border, in the Chisos Mountains? All these trees are relatively close cousins of hardwood species that still dominate the much cooler Ozarks and southern Appalachians.

In short, just as globally cooler temperatures once caused sea levels to drop so low as to reveal the land bridge across the Bering Strait, that period of cooler temperatures permitted these southeastern trees to take literal root in the Edwards Plateau. The population here is kept alive by the marginally cooler temperatures of the slopes. They persist almost vestigially, another reminder that the ecology we inherit here is recent. Further shifts in temperature will doubtlessly either push the trees to evolve to handle the higher heats, further restrict their range, or eliminate them altogether. We already find plants that historically don't grow this far north in the Edwards Plateau.

Flint and Buffalo

There's a place on our property where I always take curious people. The ground is fairly littered with fragments of flint, a stone that doesn't naturally occur on top of this mesa. Its presence, then, implies a human intervention in the landscape.

I puzzled over these fragments for the longest time. Why so many little chips? A few points are mixed in, but even those are mostly broken. I'm more likely to find complete artifacts other places on the property, but nowhere is there such a density.

An archaeologist friend suggests the word "deboutage" to describe them, the bits removed when one is shaping a flint point, knife, or scraper. Just the leftover scraps. That makes sense, but there are still some confusing issues that might argue against that. First, given the wide age range of broken points found at this location, there's literal millennia of evidence of human interaction with this landscape. Second, what would make this location such a profoundly desirable place to knap flint? The spot is about ten miles from the nearest flint outcropping that I'm familiar with (though there certainly could be some nearer). You can see for about thirty miles to the north and west from this point on the mesa, so there could be tactical reasons for sitting here, but those views are even clearer just a hundred yards or so to the north. The location is reasonably close to the spring on the property, which could be a good justification, but, again, only a hundred yards closer from a site with better views. In short, there seem to be sufficient mitigating factors against the place as a consistent flint-knapping site, and it's hard to believe this is the sole reason for the concentration of flint chips.

Another friend of mine is a bowhunting guide in the Canadian grasslands. Bowhunting is an exceedingly complex endeavor, as I understand it. All the things one must consider when hunting with a rifle are greatly magnified. You have to make sure prey cannot see, hear, or smell you; you sneak within forty yards of them; then you have to do something fairly athletic while they don't notice. This is a difficult enough operation in a landscape that offers cover, but in grasslands? He tells me he has two primary means of deception. First, move like a grazing animal, not like a carnivore, and a young animal might disregard your presence. Second, take advantage of ripples in the terrain.

Last December, just as the sun was setting, I took a rifle shot at a doe. I saw her react to the impact of the rifle shot and knew I'd hit her well, but she still ran into the cedar. Common enough. In the fading light, I went back to the house for a flashlight. Coffee and light gathered, I headed back to where I'd seen the doe disappear. As I approached the site where we find the flint chips, a young buck and I startled each other—maybe fifteen yards between us when we first noticed the other. He was standing exactly where we find so many flint chips, and suddenly I understood. That buck took the easiest path up the mesa, and the break at the top hid me from his sight until we were right on top of each other. Those flint chips aren't deboutage, they're shattered spear and arrowheads. For ten millennia, this path has been the easiest way up the mesa for deer, and, for ten millennia, someone's been waiting for them. How many of that buck's ancestors died on this exact spot?

I consider all the other pieces of the story I still don't know: Who threw those spears? Who drank from this spring? Who returned here, year after year? Was there a name for this place? Who died, and who was born here?

We live near Lytle Gap, just a low spot in the ridge where the Lytle family once lived. Two gaps away is Buffalo Gap, so named as it was the preferred gap of the buffalo on their migrations. The creek there is still marked by their wallowings. A neighbor has a buffalo skull on his wall, turned into a gun rack. His grandfather found it in the pasture. And, we're getting into hearsay here, but a neighbor thirty-five years my senior tells me that the old timers told him this mesa was covered in "buffalo parts" within their memories. For an animal that so dominated this landscape, they are very absent now. Their destruction was coterminous with the end of the free-roaming Comanche. Once the herds were gone, they acquiesced to the reservations.

Barbed Wire

White settlers didn't wait long to push their way in after the Comanche were pushed out. Just a bit to our east, in a low spot in the mesas, a sheep ranching community named Eagle Cove sprang up. The last of the buildings was destroyed in 1917, but their evidences are everywhere. My neighbor across the road moved to his place in 1940, and he has no recollection of our place ever being fenced. Nevertheless, my chainsaw skips off barbed wire deep in dead oak trees. Barbed wire is relatively easy to determine the date of; the style of manufacture changed fairly frequently in its early years. The stuff I find most frequently went out of manufacture in the 1890s.

We find rusty bits of horse tack constantly. One evening we find a large iron ring in the road, obviously worked by hand. It's the hub to a wagon wheel. The plant biologist says the cedar distribution on our property suggests it was cleared by some means other than fire relatively recently, again, outside the memory of the neighbors, but in the last century or so.

More signs of recent habitation, and the dreams of the person who owned the property just before we did: spent shotgun shells, broken Bud Light bottles, the occasional rusted tool, and construction scraps.

The changes my family has made to this landscape are immense. In addition to the house we built around the previous owner's concrete slab and steel frame, some of my Thoreau-inspired students built a small stone cabin in the back of the property. I've cleared fence lines with chainsaws and tractors and concreted posts in the ground with a rock drill and a jackhammer. I've introduced goats, sheep, cattle, and pigs to this landscape.

For all the attention I've paid, there's doubtlessly more to the story of this place that I've missed. I wonder what will be left when a grassfire inevitably burns down what I've built. Who will find the steel that my immediate predecessor welded? Who will find the pile of limestone the students called a cabin? If an arrowhead can sit undisturbed for several thousand years, surely that limestone will leave a mark.

"We're passing through," the Yacqui man told me back at the rock art site. "You've got to feel the moment that you're in. Press your hand up against their mark, and feel the buzz." Understand your context, but know that you're in this place now, too, I take him to mean. My son adds some turkey feathers to the bowl of relics, propped up between the 66 million-year-old fossil and a pottery fragment.

<p style="text-align:center">❧</p>

Jeremy Elliott studies and teaches environmental literature at Abilene Christian University. He lives with his family on the Callahan Divide, where they raise goats and sheep. He feels that biblical allegories concerning sheep and goats are largely accurate—goats are an excellent metaphor for the damned. Recent research centers on human interactions with the environment and how we use time and place when we create or read narratives. This research has paid particular attention to Lower Pecos style indigenous murals, which range from 4,000 to 2,000 years old. Recent publications have appeared in Southwest Review, Passages, Western American Literature, *and* Saltfront, *and recent presentations have taken place via MLA, WLA, and ASLE.*

Entropy

Sean Prentiss

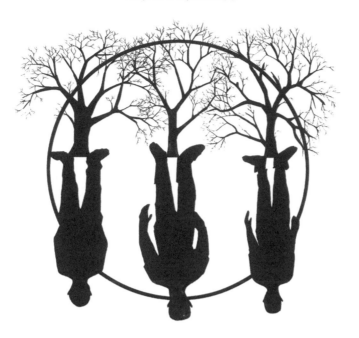

After these months spent learning wilderness,
returning again to primitive,
we remember that there is no truth
except that all things move
from balance to imbalance.

There is nothing any of us can do, no way to stop
the months of suns from arcing across
our finite & shimmering skies;
still we try to harness the sun,
to cease it from setting.

Then a long list of lasts & finals until we sling no more
dirt, until we birth no more trail, until we
[known for so long only as family]
become you & you & you & me.

One day [today] we realize that this morning walk
is our last, eight hours of throwing soil,
then a final tool count, later, the final
bastard file arced across a Pulaski's cheek;
let the edge grow dull tomorrow.

Sean Prentiss *is the author of the memoir* Finding Abbey: The Search for Edward Abbey and His Hidden Desert Grave, *which won the 2015 National Outdoor Book Award for History/ Biography, is a finalist for the Vermont Book Award, and was a finalist for the Colorado Book Award for Creative Nonfiction. Prentiss is also the co-editor of* The Far Edges of the Fourth Genre: Explorations in Creative Nonfiction, *a creative nonfiction craft anthology, and he is the co-author of the 2016 environmental writing textbook,* Environmental and Nature Writing: A Craft Guide and Anthology. *He lives on a small lake in northern Vermont and serves as an associate professor at Norwich University.*

JoHanna Spaeder

"Year on the Pond" (2017) is a visual poem capturing the changes and movement of time in the natural world around me. While the pond appears to stay the same in so many ways, every time I looked at it, it was new. Through this beautiful landscape, I learned I can go on wild adventures while staying in one place. There's magic in watching the world move by. Somehow a place can be so grounding, yet so impermanent and so new, all at the same time. My aspiration was to bring out the essence of all the different sides of one singular place. In this piece, I wanted to explore, on one sheet of paper, a place as it moves through time.

"Summer Day" (2017) is a visual poem that aims to capture everything happening in one moment and in one place, as well as a tiny bit of the environmental history. Beavers are such small creatures, but through their lives they alter their worlds. Destruction and flooding occur as beavers create homes for themselves, and beauty and new ecosystems are also created. The heat and stillness of a summer's day contrasts with all of the work the beavers have done to manifest and maintain this pond.

∽

Johanna Spaeder (she/her) is an artist at heart who focuses primarily on practicing watercolor, mixed media, and oil. She currently lives in San Diego, California (traditional lands of the Kumeyaay), where she works in university administration. She is queer and active in social and racial justice initiatives, practices meditation and healing, and regularly makes time to go into nature for reflection and inspiration. For Johanna, the practice of art is one way she interconnects her inner worlds with the people, cultures, and environments around her. During the COVID-19 pandemic, she has been most grounded by creating mixed media pieces, meditating, and walking the San Diego beaches. She spent time living in southwestern New Hampshire (traditional lands of the Abenaki) for a few years in a rural intentional community.

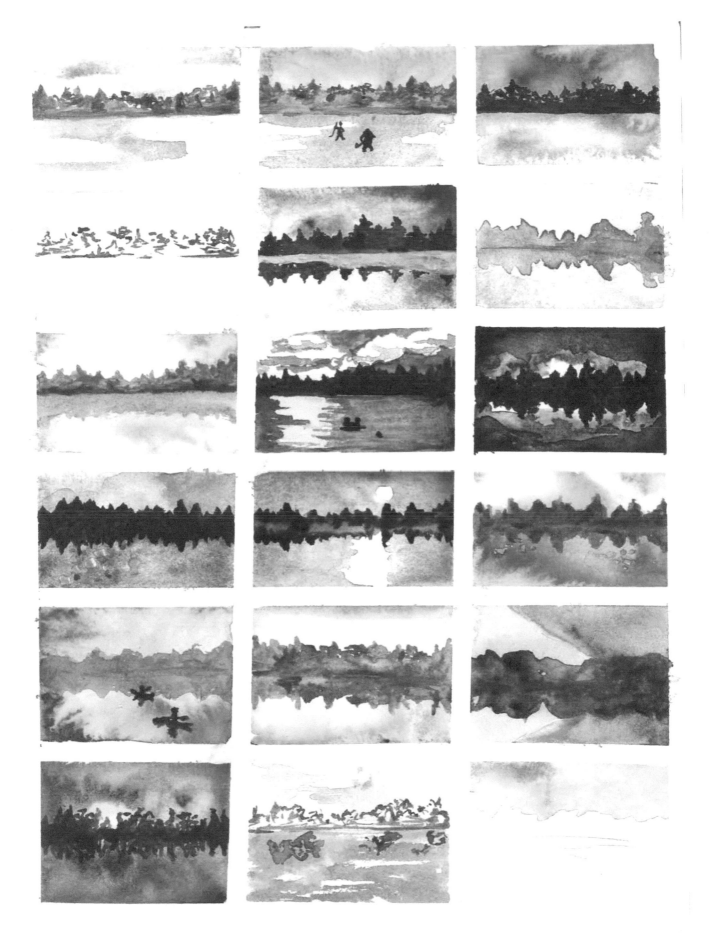

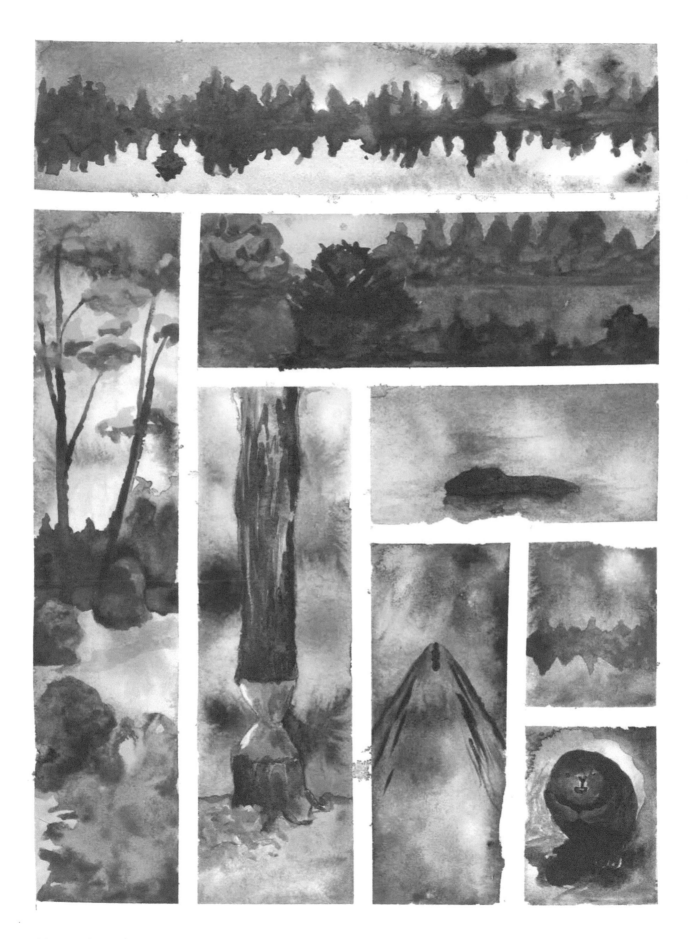

SHERI VANDERMOLEN

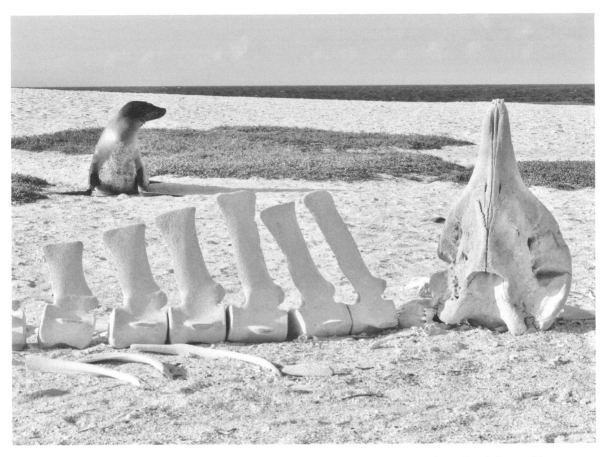

I n his October 1835 reflections aboard the *Beagle*, Charles Darwin described the Galápagos archipelago as "eminently curious . . . a little world within itself." Nearly two centuries later, the distinct natural history of this location continues to captivate visitors, whether they are exploring in the name of science or ecotourism.

Through his intense surveys, Darwin discerned the array of changes Galápagos species had made, over time and across ecosystems, in order to adapt more fully for survival. His provocative study cast world attention toward these quiet islands, and humans invariably began making their mark.

As an artist there to record rare flora and fauna, I questioned the necessity of stepping foot

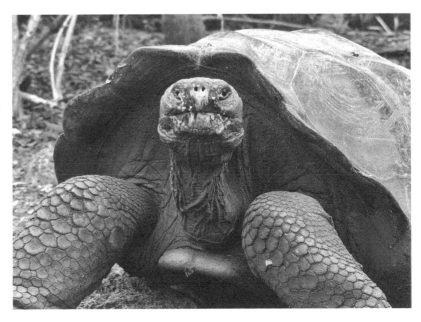

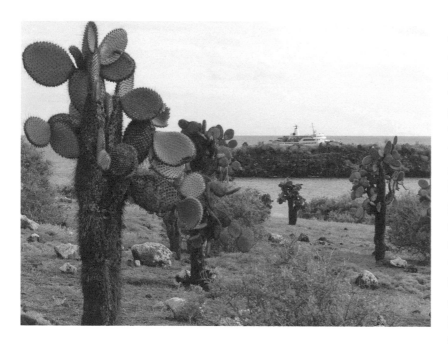

onto the terrain myself, and I grappled with mixed emotions while watching cruise ships shuttle guests to shore via pangas. Carefully traipsing the beaches and footpaths, I took heart in knowing these population-regulated excursions provide critical economic support for local ecological initiatives and that my own exploration would have meaningful impact: wildlife portraiture to be leveraged for fundraising by the Galápagos Conservation Trust in order to boost global awareness about safeguarding the region now and for generations to come.

Although I felt an incongruous mix of overt intrusion and unparalleled isolation while venturing from Mosquera to San Cristóbal, these images reflect my desire to amplify Ecuador's efforts to protect endangered species at this crucial time before it's simply too late.

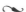

Sheri Vandermolen *began her photography pursuits in 2008 after relocating to Bangalore, India, and her work has since achieved global critical acclaim. Her editorial spreads in* Cargo Literary *and* Still Point Arts Quarterly *reflect her travels across Rajasthan, including a visit to the 2013 Maha Kumbh Mela (with 30 million attendees on a single day), and her regional shots of Myanmar have been featured in* Shadows and Light *and on the cover of* Veils, Halos and Shackles: International Poetry on the Oppression and Empowerment of Women *(Kasva Press, 2016). In 2017, her environmental imagery was showcased at the UK Royal Geographical Society on behalf of the Galápagos Conservation Trust. Also a professional author, Vandermolen paired her original digital shots with verse to create the volume* Jasmine Fractals: Poems of Urban India *(Shanti Arts, 2017). She currently resides in California, where she pursues freelance writing, editing, and photography.*

RIGHT: *Circadian Diligence*, 2018, felt on canvas (50" x 60" DIPTYCH)

Xander Griffith

If you look closely, you can see five birds in "Circadian Diligence." The woman who commissioned the piece chose dove-shaped birds in honor of the favorite bird of her father. The birds stand out when viewing the piece in person because they fly at a different depth. The rest of the picture is at a depth of ½ inch and ¾ inch, while the birds are at a depth of 1 inch. Each performs a vital task: pulling the tides, raising the sun, lowering the moon, pulling the clouds across the sky, and bringing the stars down past the horizon.

As a piece commissioned for a family, my main emphasis in this piece was on the family dynamic and how each member pulls their own weight. The day rises and falls, and we participate in the planetary rhythms, marking time based on the individual energy we each contribute to the day's work. The same can be translated to our environmental responsibilities. Each of us can shoulder an aspect of the collective work of life on planet Earth and help pull in the tide.

"Circadian Diligence" is installed at a beach house on the Oregon Coast. It is a diptych created as a joint gift for a family that owns a house together. If the day may arrive that they sell the house, both sides of the family would get one half of the picture to remember both the house that inspired it and their love for each other.

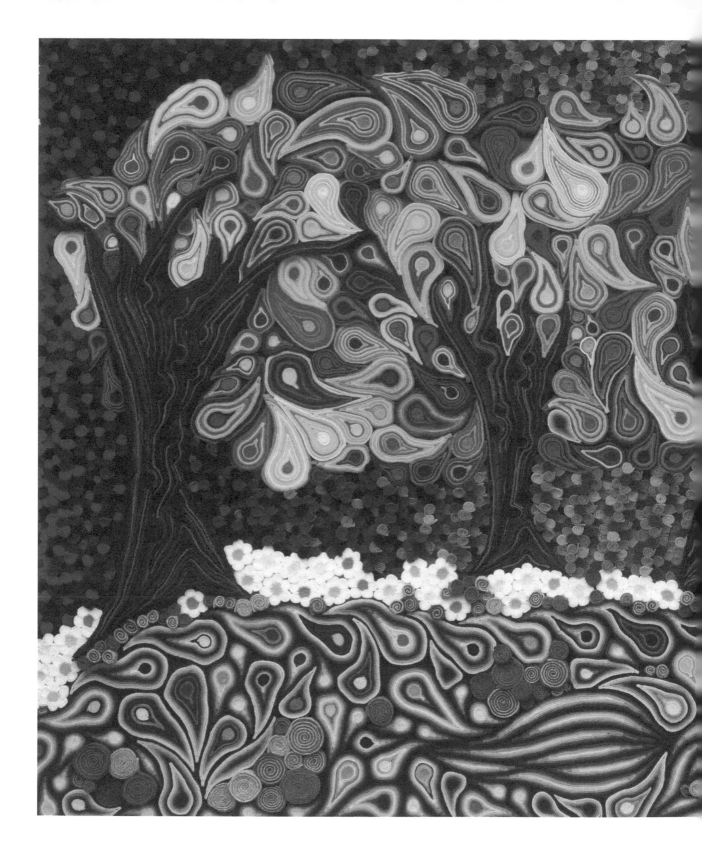

"Luminosity" incorporates a wide range of family members into a small space. The green tree leaves are in the shape of a bear (the oldest son's favorite animal), while tree limbs of the bear are the mighty grandparents that hold up and center the family. The youngest son is in the shape of a fox, hidden in the water of the stream. The father and mother are represented by the sun

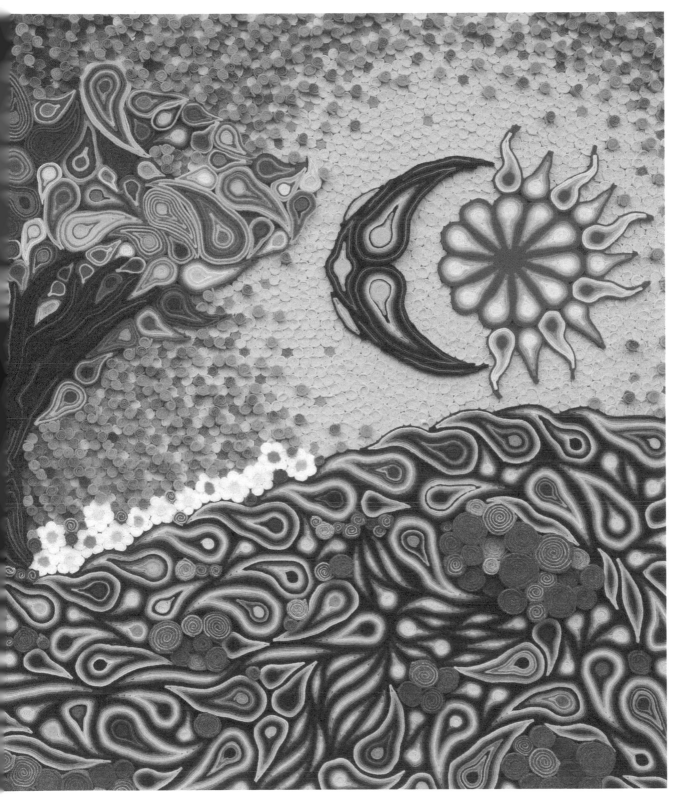

ABOVE: *Luminosity*, 2019, felt on canvas (35" x 60")
In a Portland, Oregon, private residence

and moon. The family who commissioned this piece feels deeply rooted in place with ties to different forestry departments throughout Oregon. The best way to show both their strength and common thinking was through the lens of nature.

After frequenting Salmon Creek in Vancouver, Washington, "Marco! Polo!" took shape. I witnessed all of the interactions depicted. A heron and seagull hunt a frog in the middle of the frame. In turn, they are hunted by an eagle and coyote. Nature is, at its core, a lesson in urgency.

ABOVE: *Marco! Polo!*, 2018, felt on canvas (53" x 86")

Vigilance is rewarded with continued life, while a lapse in attention can be the moment a being's time runs out. Every day is a risk, a battle for more time.

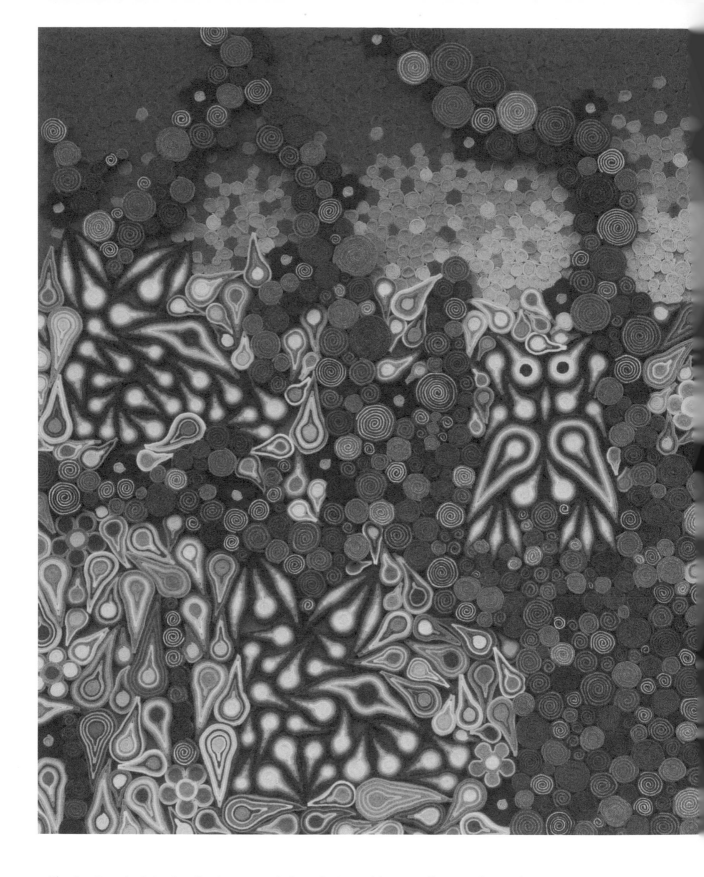

The backyard of the family that commissioned "Screeching Family Tree" housed two owls that they named Screech and Scratch. The main tree, a Texas mountain laurel tree, symbolizes the father. Hidden in the tree foliage, deer heads represent the family's three daughters, looking to

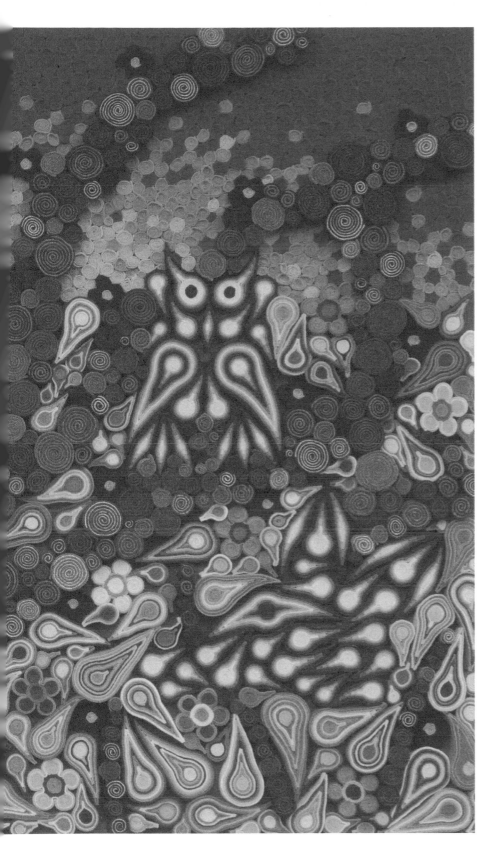

LEFT: *Screeching Family Tree*,
2018, felt on canvas (35" x 50")
*Hanging proudly in an
Austin, Texas, home*

the father tree for guidance and instruction. The owls, while very much wild animals, show the connection to the wildlife that the family holds in highest respect. The family's own little habitat flourishes through mutual care and protection.

"My Love Lies Bleeding" was created for a family of mycorrhizae scientists that helped pave the way for this field of research over 40 years ago. Labeled as heretics by their peers, they helped transform our understanding of the landscape within every clump of dirt. Mushrooms are closer genetically to insects than to plants. The interconnectivity under our feet shows how the humblest of organisms offers a vital ecosystem service, bridging everything together. Forests cannot easily survive without these important fungal networks, and these scientists brought forth new understandings of forest ecology that shifted our perspective on collaboration between species.

ABOVE: *My Love Lies Bleeding*, 2020, felt on canvas (42" x 120")
Installed in a private residence in Grants Pass, Oregon

ABOVE: *The World to One Another*, 2018, felt on canvas (36" x 72" DIPTYCH)
Installed at a private residence in Bend, Oregon

"The World to One Another" expresses the cycle of life in both nature and the family unit. The beaming sun is the father's love and oversight. The middle mountain in the range has the outline of a tiger, showing a mother's ferocious love and her constant work to move both earth and water for her child. The spewing forth from the mother's mouth is the life-giving water which, in partnership with the light of the sun, sustains not only her own offspring but also all life on the planet.

∽

Xander Griffith is a fiber artist using the medium felt. Based in Vancouver, Washington, the first years of his artist career he worked in conjunction with regional Burning Man events. Griffith and his girlfriend created a one-of-a-kind disco ball that was accepted at the Portland Winter Lights festival. Exhibitions and permanent installations of Griffith's art have graced the Portland International Airport, Rose Haven, Ascend Tattoo, The Ronald McDonald House of Charities in Tucson, Arizona, and the forestry department of Oregon State University.

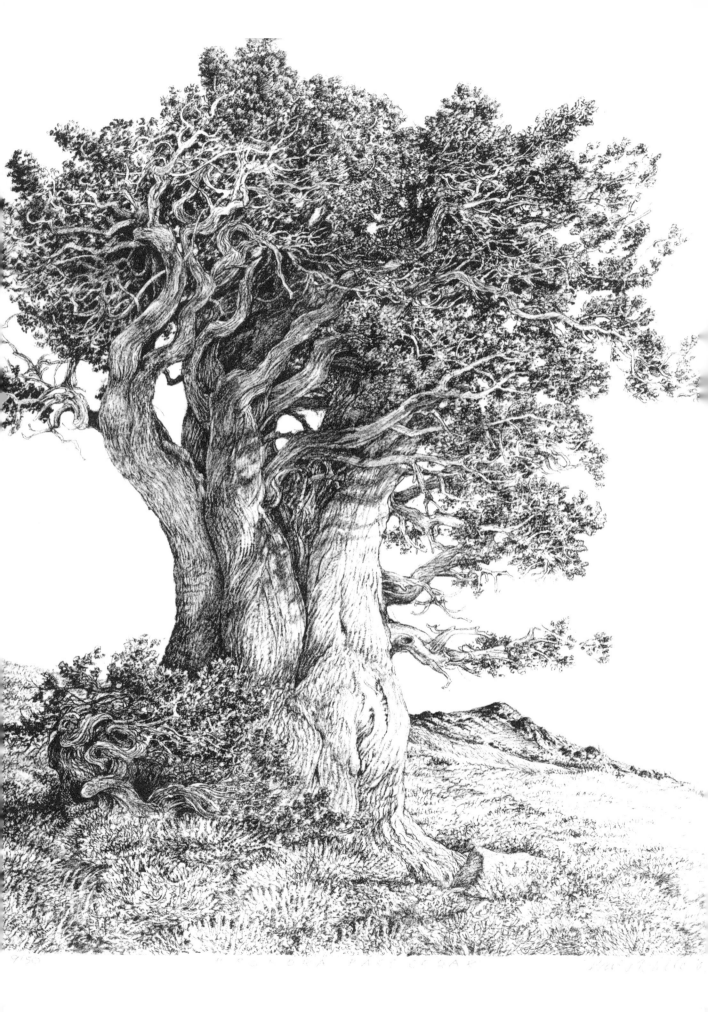

DAVIS TE SELLE

The tree depicted in "Sonora Pass Cedar" is a beacon of endurance near timberline on the eastern, dry side of the Sierra Nevada mountains of California, just north of Yosemite. A long-standing landmark of Sonora Pass, this tree reassures travelers who see its steadfast presence as they near the summit of the pass. Its arresting beauty and graceful stature finally called me to pause in my transit and take the time to meet it personally. The result is this lithographic print.

For me, to draw trees is a contemplative practice, calling me to reflect on the time it has taken the tree to come into its present state. Drawing offers me a way of reading a tree's autobiography. Over the years, I have made many works focusing on ancient bristlecone pines, such as the print "Fudo, the Bristlecone Pine." This tree stands as a kind of gatekeeping guardian to a precious grove of ancient bristlecone pines in the Ancient Bristlecone National Monument. I called this tree *Fudo* because when I encountered it, I felt a presence akin to the Japanese temple guardian spirit of *Fudo Myo-o*, "The Unmovable," admonishing me to enter that venerable stand only with proper respect and humility. Something fiercely primal permeates the air in and around these ancient ones.

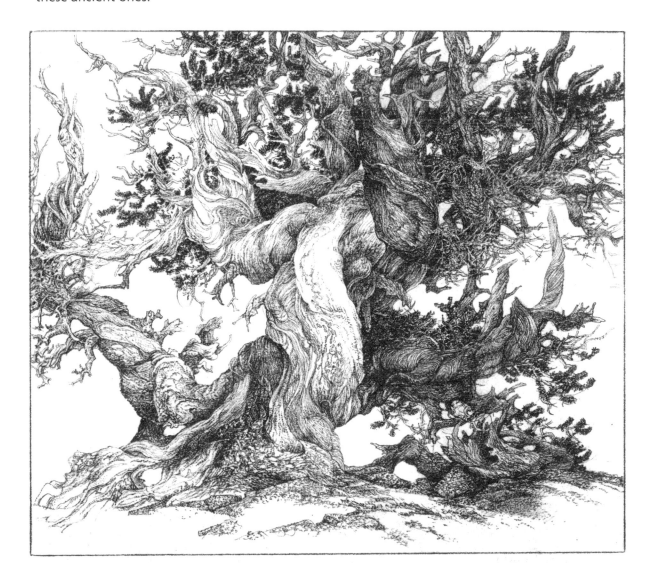

Of all hand printing techniques, lithography most honors the range of expression in the draftsman's hands, which is one reason I chose this medium. Lithography requires a considerable amount of time spent by the artist. I've long been attracted to earlier forms of print illustrations, especially nineteenth-century scientific illustrations. Often these are lithographs, etchings, or engravings. These works manifest the rewards of careful and attentive study by bygone artists. My main guides from the Western tradition have been the natural history and landscape artists of the eighteenth and nineteenth centuries. From the Eastern art traditions, I have been inspired by Chinese and Japanese masterly brush painters of Sung Dynasty mountain landscapes. These paintings evoke more emotional feeling states. The depth and richness of informed detail I see in nineteenth-century Western illustrations mixed with East Asian influences challenge me to aspire to bring these qualities together in my own artwork.

My own images are printed using both classic and experimental lithographic techniques with the consistent aim of achieving a pencil quality in the final prints. Recently, I have been drawing on hand-ground glass plates, which yield similar tonal sensitivity as traditional limestone. This process creates prints combining the clarity and incisive line of etchings with the soft value range of lithographs.

∾

Davis Te Selle *taught nature drawing and printmaking at University of Vermont and currently has a printmaking studio in Portland, Oregon. He has shown his work in group and solo exhibitions on both East and West Coasts, and his work has appeared in numerous conservation publications such as* Orion Magazine *and* Wild Earth. *His lithographs of trees are featured in* Conversations with Trees: An Intimate Ecology *by Stephanie Kaza, republished in 2019 by Shambhala Books. Te Selle attended California College of Arts and Crafts and holds an MFA in printmaking from San Francisco Art Institute. He is a two-time recipient of the prestigious James D. Phelan Award, one for drawing and one for printmaking. For more information, see* www.davisteselle.com.

Legends of the Common Stream
John Hanson Mitchell

There is a stream bank below my house where forget-me-nots bloom and turtles and otters slip through the dark waters below the high ground. Almost every day for twenty-five years or so I have trekked down through the woods to this isolated spot to watch the course of the seasons, the comings and goings of the wildlife, and the flowering and fading of the local plants.

I went there just before dawn on Christmas morning last year to watch the day unfold. It was a day not unlike any of the other days that I visit the place, except that it was the official beginning of the winter season. The sky was cloudy, and the air was filled with that close, watery scent of coming snow. Down at the brook, the grass on the bank was still snow-free, and I sat cross-legged above the waters and waited for sunrise.

In fact, there was nothing to wait for; this day was characterized by that flat, seamless pall of gray sky that prefigures snow. A few flakes began drifting down, followed by a few more flakes, and then by a steady but light fall. As I watched, a pale, faded image of the white winter sun, much filtered through the mists and drifting flakes, showed itself, a silvery coin behind the black branches of the trees beyond the brook. It was an odd, somehow portentous sunrise, the type of light into which the native shamans and Puritan ministers of these parts might read dark omens.

Christmas is, of course, a major holiday for Christian cultures and also the day that marks the beginning of the Christian Era in the Gregorian calendar. But shortly before the historical birth of Christ, this same date was celebrated by a Roman cult of Mithra, who was not exactly a god but the earthly representative of what his followers believed was the true and only god—the sun.

Five thousand years before Mithra and the Christian Era, among cultures all around the world, this day was celebrated as a solstice festival, a critical celestial event. Before the advent of organized religions, our Cro-Magnon forebears watched the fading light and shortening days with dread. It was not clear that the sun would not carry on in its decline and never return. To halt this process, shamans, holy men, and priests would carry out certain rituals. In fact, the solstices may be among the most important events of the human experience. Archaeologists have discovered an animal bone in Siberia that Cro-Magnon people intentionally marked with scratched symbolic lines. It was determined that the lines were associated with some sort of primitive calendar created in order to track the seasonal progress of the sun and moon. This is considered the earliest evidence of human consciousness of the regularity of celestial changes.

At the time of the winter solstice in ancient Egypt, pharaohs—who were considered the earthly embodiment of the sun—used to perambulate the temple walls to encourage the real sun in its daily course. And, each year at Rhodes, the ancient Greeks would cast a chariot and four horses into the sea to refresh Helios' worn-out team who drove the chariot across the sky each day and sank in the western seas at dusk.

Most of these seasonal celebratory events involved fire, the thought being that the fiery sun would be nourished by earthly light. Some local Native American tribes would shoot burning arrows into the night sky at this time of year and light fires, torches, and candles to assure the sun's return. Although the origins are long forgotten, even in our time as the days shorten, strings of Christmas lights are illuminated, and menorah candles are lit.

Here, beside the stream, in the silence of the drifting snow and the quiet flow of black waters below the bank, you get a sense of deep time in the course of human history. On mornings like this, the peace of wild things descends, time stalls out and even runs backwards on certain days, so that I could be sitting here in the Pleistocene, when this stream was first created by glacial melt waters, giant beavers coursed the waters, and mastodons grazed the uplands. Or I could be here three hundred years ago, when a tractable old Pawtucket man named Tom Doublet tended his fish weir not far from this bank.

Doublet was a Christianized Indian who around 1650 had been converted by the teachings of John Eliot, the so-called apostle of the Indians. In spite of his new faith, Doublet would have been familiar with all the old legends and myths associated with the changing seasons. December for him was the Deer Moon, the month when the gray-brown herds of deer collected. While tending his fish weir, he would have commonly seen otters, the winter-bringer of Algonquian tradition. The winter wrens and golden-crowned kinglets would have been active in the thickets of buttonbush, and, if the ice was clear, or the stream as yet unfrozen, he might have seen the shadowy form of a wood turtle slipping by along with beavers and muskrats and mink. Many of these plants and animals would have been associated with legends and folktales, would have formed a deep connection with the natural world, would have been companions almost, in the vast cycles of time and the seasons.

Until the invention of the radio and the wide, and now instantaneous, access to various electronic media, all these differing cultures had stories of the interconnections between the natural world and the world of human beings. Folktales and legends have a way of breaking down the barriers of time and space, overcoming the sense of otherness, of separation between the world of nature and the human world.

In Doublet's time, the native people still told tales involving now-extinct animals, including the woolly mammoth. A story from this region, for example, takes place when human beings and animals were smaller than they are now. One much larger group of animals, the Yaquaways, giant red-haired, four-legged creatures with long trunks and saber-like tusks, were ruthless tyrants and ruled over their smaller subjects. Finally, the animals and the people rebelled and made war on the Yaquaways. The final battle took place in a great marsh, and the people and the animals appeared to be losing, but in the midst of the fighting, a flooding rain began to fall and the ground became so soggy that the heavy Yaquaways sank into the earth, never to be seen again, while the smaller living things survived. The battle took place in autumn, and to this day each year, the cranberries turn blood red in memory of the great war.

Bears in particular have played an important role in rituals and legends partly because they are plantigrade and partly because they occasionally stand up on two legs. Bear legends were carried to the American continent from Siberia over fifteen thousand years ago. Here in Tom Doublet's territory, a local story tells of an ancient shaman, known as Paukawna, who could turn himself into a bear. If our local town histories are accurate he seems also to be able to transcend the shackles of linear time. There is a record of a huge bear killed by a farmer in 1811. According to a witness named Johnny Putnam who was there when the bear was shot, shortly before (or after) his supposed death, the bear transformed himself into a human being.

One could go through the year tracing, from the singular point of view of my place beside the stream, the rich diversity of the tales from around the world that record the seasonal changes. In fact, many of the natural events that occur during a year were connected to specific

animals—otters, bears, beavers, bluebirds, crickets, herring, ladybugs, snakes, turtles, and spider grandmothers all had connections with seasonal changes—until the present era arrived, and after that they passed into obscurity.

Folktales and legends of this sort seem irrelevant in our scientific age, but they not only tie us to the natural world, they are, in some ways, reliable environmental histories told in a metaphorical language. More locally, and more significantly from my point of view, tales from the stream bank where I spend my days tell of a vast fight between a frog monster who lived on the western side of a huge lake and a Native American hero called Glooscap. The battle so shook the earth that the impoundments that held back the lake water burst and the lake drained off. According to geologists, after the glacier retreated, there was indeed a lake in this region, and it did suddenly drain off. In its place, it left behind, among other geological structures, the winding stream where I spend my idyll hours.

∽

John Hanson Mitchell was the founder and editor of the award winning journal, Sanctuary, *published by the Massachusetts Audubon Society. His book,* Legends of the Common Stream, *from which the essay was adapted, will be published by UMass Press in late April. Mitchell is winner of the John Burroughs Essay Award for his* Sanctuary piece, *"Of Time and the River." In 2001 he won a Vogelstein grant for* Following the Sun. *He received three different grants for his work on* Looking for Mr. Gilbert, *and was awarded an honorary PhD from Fitchburg State University for his work on the book* Ceremonial Time. *In 2000, he was given the New England Booksellers' Award for the body of his work.* Legends of the Common Stream *is the latest in a series of six books based on the square mile of land featured in* Ceremonial Time, *called "The Scratch Flat Chronicles."*

Crossing Thresholds in Yellowstone

Kimberly Langmaid

It's a warm July morning. My curiosity and concern have lured me to northern Yellowstone's Gallatin Mountains, a range of rugged, black, volcanic peaks where open river valleys are home to deer, elk, wolves, and grizzlies. I've come to bear witness to what scientists are calling a "threshold event." Ancient groves of high-elevation whitebark pine trees are under assault and losing the battle to swarms of ravenous bark beetles. Expanding armies of these flying insects have been unleashed due to the warmer winters of climate change. The iconic Yellowstone forest ecosystem of pines, birds, squirrels, and grizzly bears is crumbling.

Before leaving home in Colorado I made plans to meet Dr. Jesse Logan, a retired Forest Service scientist who can show me the changing forest firsthand.

I arrive at Jesse's home just after daybreak. The sun is low and sparkling on the nearby Yellowstone River. Jesse welcomes me with a hot cup of coffee. He is dressed for the day's adventure, wearing hiking boots, gaiters to protect his ankles, an elastic black knee brace, long khaki shorts, a blue plaid shirt, and a well-worn ball cap. His serious and determined scientific demeanor is softened by his warm smile, rosy cheeks, twinkling eyes, and graying goatee. As he finishes slathering on bug repellent and loading his backpack with lunch and gear for the day, he turns and hands me a black holster containing high pressure pepper spray. "We'll be hiking through grizzly country; you're going to want this handy."

During most of his career as a top Forest Service entomologist, Jesse studied the relationships between insects and trees. He also followed his passion for the outdoors. As a young scientist he matched his knack for mathematics with skills in ecology. Then he took his expertise to the mountains: he wanted to play a positive role and help with the future of our national forests. Ahead of many of his colleagues, Jesse discovered a worrisome pattern and predicted a dramatic shift on the horizon. Data from his research on Rocky Mountain pine forests led him to forecast a serious climate change impact before anyone else saw it coming. Now, almost a decade later, he is taking me to see the damage underway.

We load our packs into the back of Jesse's white 4x4 pickup and head for a high-elevation whitebark forest in the Gallatin wilderness. After driving several miles through an open valley of picturesque Montana ranch land, we turn onto an old logging road and begin zigzagging our way up steep switchbacks. Jesse carefully navigates the potholes and waterbars in the rough road while I brace myself in the rattling pickup cab. I clench the handle above the window and stare down at the green valley fading in the distance below. My mind jitters like the truck, levels of awareness jumping from the jarring ride up the switchbacks, to the depressing forecasts of climate change, to a mounting fear of hiking through grizzly territory with a man I met only an hour ago.

I feel myself peering over the edge of a threshold. The Latin word for "threshold" is limen, as in limit, border, or boundary. Philosopher Jeff Malpas describes our lived bodies not as objects but as "movement across," as the very condition of liminality. Malpas, who approaches philosophy through topology and place, suggests we are always

in a state of motion, always "in advance" of ourselves, given over to our inherent sense of temporality. Thus, our sense of self is determined by time, not only by our history, but primarily by what lies ahead. Our bodies are oriented by the possibilities of place and time. Our embodied liminal character constantly moves us forth into the world, never at rest. Like passing through doorways, we live our lives crossing one threshold to the next.

❧

We've climbed hundreds of feet up the mountain when Jesse parks the truck, and we've still got at least an hour's hike to reach the high-elevation whitebark pine forest. Jesse straps on his backpack and leads the way up a faint trail, weaving his way through a thick forest of subalpine fir, spruce, and lodgepole pine. So far, there are no signs of grizzlies. No scat, no overturned logs, no

dug up squirrel middens. Intent on keeping up with Jesse, who quickly gets ahead of me, waltzing over deadfall, ducking under branches, and skipping his way through the undergrowth of the timber with the ease of a leprechaun, I focus on my breath and hike steadily to the cadence of crunching dry twigs and pine needles.

The air is still. Thin spears of sunlight pierce the evergreen canopy and illuminate the shaggy forest floor. It's almost noon, and the intense summer heat penetrates the forest, releasing the tangy smell of terpenes from the evergreens. The aromatic chemistry of mountain spruce and fir prickles my nostrils and awakens my primal mind. Being in grizzly territory heightens the senses; I tune in my peripheral vision to catch any sign of animal movement. I pick up the pace, acutely aware of no one else behind me.

❧

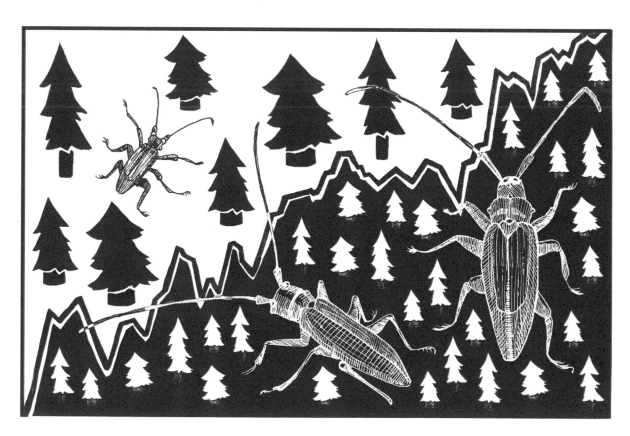

In our human liminality, we are always caught between a state of entry and a state of departure. Malpas says our lived bodies "reflect the character of the threshold as that which joins the strange with the familiar, the foreign with the domestic." The threshold is not the focus of our attention; when we shift our attention to the threshold itself, our movement is hindered, and the function of the threshold as point of entry, or doorway, is diminished.

∽

The mood of the forest shifts as Jesse and I finally approach a stand of high-elevation whitebark. A calm, magnetic spaciousness emanates from the forest and beckons us deeper. A grove of towering, gray, gilt silhouettes merge their ancient evergreen branches into a collective crown shimmering above us, the sunshine highlighting clusters of crimson dead pine needles. On the ground are soft leafy pillows of green grouse whortleberry and the scattered golden faces of heart-leaf arnica daisies. The forest is silent except for the faint distant tapping of a red-breasted nuthatch searching for beetles up and down a ravaged tree trunk.

Jesse approaches one of the largest old whitebarks. Standing tall in its sylvan majesty, and nearing its death, the tree dwarfs us, its gnarly old bark showing the tell-tale signs of beetle attack, its enormous trunk riddled with tiny beetle entry holes. Small yellow curds of drying pine sap and scuffs of ragged bark cling to the dying tree. Around its base lie small heaps of powdery frass—sawdust discarded by the tunneling beetles. Jesse unsheaths a hatchet from his belt and deftly hacks a hand-sized scab of bark. Revealed beneath, in a shallow vertical groove, a tiny black beetle the size of a rice grain lies in its final resting place. Just below it, a wriggling white larva struggles from exposure to the sunlight. It's humbling

that these tiny insects can kill hundreds of square miles of tough old trees in just one season and decimate Yellowstone's most iconic forest ecosystem.

While bark beetles and pine trees have evolved together over thousands of years since the last ice age, with the beetles playing an important role in maintaining the health of forests, the current beetle infestation is outside the norm due to warming temperatures. Pine bark beetles are specialized predators. Adult beetles use their crushing mandibles to bore their way under the bark of the largest trees and tunnel an elaborate series of galleries where they lay eggs. A fungus introduced by the beetles eventually clogs the galleries and chokes the trees if the trees aren't strong enough to push the beetles out with their sap. Jesse calls the beetle outbreak in Yellowstone "the fire that won't burn out."

In high-elevation whitebark forests, winter climate is everything. The timing and rate of the beetle's cold-blooded life cycle is controlled by thermal boundaries. When winter temperatures are cold, beetle populations are kept in check, and the native insects serve as regulators of forest renewal, taking out only the weak trees and helping sustain a resilient forest. When winter temperatures are unusually warm, the beetles accelerate their life cycles and reproduce in exponential proportions. With warmer winters and drier summers becoming more common in our changing climate, the evolutionary arrangement between beetles and western pine forests is shifting. The beetles have grown their armies and expanded their territories, launching mass attacks and infesting pine forests throughout the Rocky Mountains. Like soldiers on a mission, bark beetles synchronize their forces, communicating with one another through an airborne cartography of chemical messages. The scale and magnitude of recent climate-

induced beetle attacks on whitebark forests is unprecedented.

"This threshold event will leave a legacy for hundreds of years," says Jesse. "I thought this was something my kids may see in their lifetime but not something I was going to experience."

In the somber silence of the dying forest, Jesse walks away from the old whitebark and points down at a lumpy dark pile of dry grizzly scat. "Must have been from last summer," he says. "A healthy whitebark forest is usually such a loud and vibrant place. Clark's nutcracker jays are flying around, squawking and raising hell. Red squirrels are up here in the fall. When there's a good cone year, it's just a rain of cones, and the squirrels are chattering. You see fresh evidence of grizzlies raiding squirrel middens. It's just a live, wonderful, marvelous place.

"And then you start to see it fall. It gets deathly quiet. There aren't birds. There aren't squirrels, no bear tracks; it's just stick forest, and the contrast is striking. It's heart-wrenching. It's not right what we're doing. This is a result of our actions as a society."

∾

As we cross the many thresholds relating to global climate change, what can we learn from our temporal nature? Malpas says our liminal, embodied way of being "evokes forgetfulness and even loss." And in our threshold state of "betweenness," our sense of loss can be equaled with a sense of hope. Birth and death bound our liminal existence, each a threshold of "coming-to-be or passing-away," with our embodied existence as an eternity of thresholds from the past to the future. As human beings, we are essentially oriented toward movement and change in the world. Yet, in this liminal, temporal orientation, Malpas says we "always stand in relation to a singular location, a place, a topos . . . there is no limit without place, and no place without limit."*

∾

In the silence of our thoughts and the too-still forest, Jesse and I hike up to a clearing at the top of the mountain. From the ridge we look out at the exposed ancient black lava flows and crumbly jagged talus that make up the high peaks of the Gallatins. Melting patches of snow remain from the past winter. And for as far as we can see, miles of red and gray dying whitebark trees stand.

Jesse ventures, "I grew up spending summers fly fishing with my dad and brother. The Rocky Mountains are absolutely basic to who I am. I guess you could say this beetle outbreak has had a spiritual impact on me."

Absorbing the devastating view of the forest, I can find no words of solace. The thresholds of climate change are new to each of us. We can love and care for our places and one another. We can acknowledge limits, be courageous, and step into the unknown together.

*Jeff Malpas, "At the threshold: the edge of liminality," Philpapers: Online Research in Philosophy (2008), http://philpapers.org/rec/MALATT.

∾

Kimberly Langmaid, PhD, is associate professor of sustainability studies at Colorado Mountain College, founder of Walking Mountains Science Center, and currently mayor pro tem on the Vail Town Council. She earned her PhD in Environmental Studies from Antioch University New England.

13 Letters to Crater Lake

Liz N. Clift

1.

Dear Crater Lake: The first time I met you, it was August and the pasque flower was mop-headed. The air smelled of conifers and was that perfect temperature, where a jacket was too much in the sun and not enough in the shade. The air glittered with butterflies.

2.

Dear Crater Lake: Before you were Crater Lake, you were Mazama, thus named by a climbing group. And before that, you had a name given to you by the Klamath, and before that who knows. All our names are eventually lost to the slipping days.

3.

Crater Lake: Once, when I visited you, I lined up pumice of different color on a lichened rock. This is how I understood stratovolcano best. White, peach, yellow, orange, red, black. That time, as I drove away, I noticed the different patterns of your ash, the layers made visible when they cut the road.

4.

Crater Lake: They say when you erupted 7,700 years ago it was 42x greater than when Mount St. Helen erupted in 1980. It was so massive that you blew off your own top and the caldera formed.

How long did you know it was coming?

In those first days after, did you know you would become so beautiful?

5.

Dear Crater Lake: Once I knew a man who was a park ranger, who spent the summer I first met you patrolling your caldera, your forests. I wanted to believe you'd lent him some of your magic.

6.

Dear CL: That man, the park ranger, wasn't a good person.

7.

CL: After the park ranger destroyed a part of me, I turned to you. I stood on the snowy bank of your caldera, near the lodge, and thought of stories he'd told me about rescues. Stupid hikers who'd hiked too close to the edge.

I wondered how many of them had been trying to perfect their swan dive, hoping for grace.

8.

Dear CL: People have a habit of saying what doesn't kill you makes you stronger. I hate that platitude.

What if you're forever fractured?

Would that be so bad?

9.
The last time I visited you, it was with a man I love. He sat on an outcropping and stared into your vastness. He'd moved to Oregon to save me or maybe to save himself.

For a long time, I thought there was a difference.

Even in photos, the shadows are long.

10.
When you exploded, people were just beginning to cultivate Malta. People were just beginning to smelt copper.

These things would change the world.

11.
A friend who restores prairies and ponds and estuaries told me he does the work he does because he loves the idea of restoring the things we screwed up.

There is so much we've screwed up.

12.
Dear Crater Lake: Once upon a time, were all the world's waters so blue?

13.
Dear Crater Lake: Before I left you for the last time, I climbed the watchtower, and watched the sunset.

How beautiful the sunsets must have been, once the sky cleared, after your massive eruption.

There is so much beauty in the world.

I so often forget to look for it.

∾

Liz N. Clift holds a Master of Fine Arts from Iowa State University. Her poetry has also appeared in Rattle, Hobart, Passages North, and elsewhere. She lives in the Pacific Northwest.

Reflections on Houston in a Time of Contradiction

From a city strangled by fossil fuels, a call to fight for a more equitable future

Samantha Harvey

In New York City, where I live, it's easy to ignore the rest of the world. Floods, fires, famines reach us via the ticker at the bottom of TV news reports, but meanwhile our stores are stocked, our billboards shine, our sidewalks pave over forgotten streams and tree roots. Even when Hurricane Sandy struck our own backyards, many New Yorkers continued to eat and sleep well above 42nd Street. And last summer, when migrant children were secreted into an East Harlem shelter in the dead of night, the majority kept moving, turning newspaper pages on the tops of treadmills, in coffee shop lines, between poles on crowded subways.

It might be human nature to tune out disasters that don't affect us directly. But in this globalized world, one crisis wraps up in the next; hurricanes and family separations are merely different symptoms of a shared root cause. So when Donald Trump rang the alarm bell on immigration and declared a "state of emergency" in the border town of McAllen, Texas, in early 2019, my thoughts turned to the nature of "emergency," the connections between humanitarian and climate crises, and the days I spent just 350 miles away in Houston prior to Hurricane Harvey.

I grew up in the Midwest and have spent half my life in New York City, so I was neither cowed by Houston's skyscrapers nor confused by the hospitality of a Southern city's people, familiar as the unsolicited smiles Midwesterners give complete strangers. Because of this, perhaps, I found Houston comfortable, utterly pleasant, welcoming, warm, easy, and yet The downtown streets at night were deserted, wide, and silent. The ten days or so I spent there transpired strangely, feeling at times much

longer than ten days, flipping dramatically between blasting air conditioning and sopping gulps of hot humidity, women and men in slick suits with shiny shoes, women and men in drab clothing covered in dust, or seen from afar framed by open flames on pits of scrap metal.

With the relentlessness of the heat in Houston, the stark discrepancy of bright cleanliness with belches of pollution down the road, I could see in sharper focus the inevitability of a future many are already living, a deepening divide between "insiders" and "outsiders," the last gasps of an industry that suckles while it strangles. And today, as the shock of 2017's Hurricane Harvey has transformed into the familiar monotony of government bureaucracy, as Houston has been pushed back in the disaster queue by Puerto Rico, California, North Carolina (and the list goes on) by an increasingly normalized, plodding clean-up saga and the despair of lives lost and put on hold, today it is up to all of us—victims and witnesses alike—to name the connections between these crises and fight for a more equitable future for all.

I'd traveled to Houston in October 2016 to attend a series of meetings led by the Building Equity and Alignment for Impact initiative and hosted by local group Texas Environmental Justice Advocacy Services. The meeting brought together grassroots, national "green groups," and philanthropy with the goal of building alignment around the then-developing Clean Power Plan (CPP), that late Obama-era rule that would have put limits on a sector of power plant emissions but still fell short of addressing the kinds of site-specific reductions and long-term health implications important to communities living on the frontlines of dirty industry.

At the time, the CPP seemed wholly insufficient. (Of course, none of us had any idea just how blatant and unapologetic the following administration would be about abandoning frontline communities, dropping out of the Paris Accord, appointing industry insiders to head the Environmental Protection Agency, opening sacred indigenous lands to drilling, and more.) In Houston, the communities represented by environmental justice (EJ) groups were mostly immigrant, low income, and communities of color, each unduly threatened with incarcerations and deportation, often bereft of their rights, and stuck living and working in the backyards of power plants, landfills, and incinerators. In short, the EJ groups were hit first and worst by fossil fuels and climate change, experiencing the twin effects of the moneyed cabal of oil and gas CEOs who, overwhelmingly white and male, control the dirty actions and green-washed messaging behind the industry.

The meeting attendees hashed out the CPP in downtown Houston, sitting inside the conference rooms of a sparkling clean, air-conditioned hotel with flowers and bowls of mints on the tables. Each shining tile and lobby armchair seemed designed to shield guests from the knowledge that this oasis was both dependent upon and deep within the belly of the fossil fuel beast. Just a few steps out the door were mazes of skyscrapers bearing names of extractive industry companies from all over the world. And just a short drive from the hotel were the Houston Ship Channel and Manchester neighborhood, thick with contaminated schoolyards, residential windows permanently shut against stinking air, and mountains of scrap metal leaching smoke and particulate matter.

The CPP meeting convened at the same time the Standing Rock camp in North Dakota was at its height, bringing together native tribes and allies from across the country to block the Dakota Access Pipeline from plowing through native prairie lands, farmland, a sacred burial site, and community water supplies. While we strategized ways to strengthen climate policy against emissions already poisoning the atmosphere, friends one thousand miles away—with their own troubled histories of colonialism, displacement, and criminalization—were hunkering down for what would soon become a life-threatening fight against government-sanctioned violence and corporate surveillance.

Energy Transfer Partners (ETP), the monolith behind the Dakota Access Pipeline, had headquarters in Houston just minutes away from the hotel where the CPP meeting was taking place. One day we all took a break to protest, walking the long blocks in the beating sun holding posters reading: "No DAPL" and "Water is Life." When we reached the ETP building, it was like all the others: rectangular, catapulting, and impenetrable. The only way to differentiate it from other companies was the name carved in the granite sign on the small, manicured lawn outside.

"Shame!" we shouted, when we reached a stopping place across the street. "SHAME!" We screamed at the building and pointed accusatory fingers at the windows, even though the mirrored treatments reflected our own images back to us. We had no way of knowing if anyone inside saw us, or heard us, or even stopped to glance at our posters. An immutable security guard stood out front, dark glasses covering his eyes. Eventually we turned around and walked back to the hotel.

That night of the protest, bothered and dissatisfied, I ventured out alone to get another look at those glass-faced skyscrapers. Even without the Texas sun, the hot air blanketed my nose and mouth, and I was quickly covered in a layer of slow-moving sweat. I walked with the hotel to my back and took a right turn at the light as I remembered we'd done earlier in the day. But I quickly lost my way, gazing down one silent street

and then another, walking faster and then doubling back. The streets were empty, and I began to feel threatened in a way I've never felt in New York. The homogeneity of the buildings' façades and the underlying lull of their nighttime hum made it hard to discern how far I'd walked from the bright hotel lobby, with only the names of energy companies on the signs outside to illuminate the boulevards. Red lights blinked remotely from security cameras recording the empty foyers of the buildings, the legs of my journey differentiated only by the shifting colors of this ghostly pallor.

By the time I took that solitary nighttime walk in the streets of Houston, I'd learned a little more about the scope and ubiquity of the contamination in low-income neighborhoods of the city. Earlier in the week, Texas Environmental Justice Advocacy Services (TEJAS) led a small group of out-of-towners on one of their "Toxic Tours," a multi-stop drive through some of the parks, schools, and neighborhoods flanked on all sides by refineries, chemical plants, and Superfund sites, less than an hour to the east of downtown. Perhaps more sobering than the lists of contaminants, recited at each stop with practiced detail by the TEJAS tour guide, was the short distance between stops.

In the beginning, the group gasped, "How is this possible?" We narrowed our eyes in disgust and piled back in the van, only to climb back out almost immediately. After the third or fourth stop we were quiet; we stopped exchanging looks. The sites of massive contamination were so close together, creating such a concentrated soup of toxicity. The unyielding tenacity of TEJAS and other environmental justice groups living at industrial ground-zeroes came into sharper focus. This was an uphill battle and a non-negotiable one; this was a fight for life and death.

A couple of hours in, the van pulled off into the parking lot of an elementary school so a few of us could use the restroom. It was a weekend and the school was empty, but our tour guide knew someone working inside. She opened the door for us and led us through the gymnasium, past a corkboard on the gym wall that had been converted into a kind of shrine to a young student, a girl who looked to be about six years old. The board was completely filled with photographs. In one, the girl held a stuffed doll, and in another she giggled as she got her toenails painted. In another, she sat in a hospital bed with an IV in her arm. Even in this one, she smiled. Well wishes and messages of hope surrounded the photos on the corkboard. The employee informed us that the school used this board to honor students and neighborhood kids who had died.

In that moment, in the eyes of the little girl and ghosts of friends who had preceded her, statistics of elevated rates of rare childhood cancers in the immediate vicinity of the petrochemical industry became more than numbers on a page. Our group returned to the hotel with a new lens; everything was sparkling clean, and everything was toxic. Everyone was friendly and yet going about their days as communities down the road suffocated.

But I don't blame Houstonians. To be American, no matter where you live and work, is in one way or another to be a hypocrite. We incarcerate asylum seekers while our "Mother of Exiles" beckons "huddled masses" on the plaque below her skirts. We guzzle fossil fuels despite having access to viable renewable alternatives, despite recognizing the ways extraction turns communities unlivable through climate change, toxics, and environmental racism. Many feel helpless to stop these systems or that unplugging any less than 100 percent is living in contradiction, dismantling the system with one hand while continuing to support it with the other. Unable to drop out completely and live off the grid, aside from the few skilled enough,

or brave enough, or safety-netted enough, we are all complicit in some way. We have little choice but to participate.

Initiations often involve some act of violence or humiliation for this same reason—to prove that you are no better than us. And once that's been proved, the ability to complain, to protest, to suggest a better way, has effectively been removed. Environmentalists are often discredited because they still fly in airplanes and use computers, fossil fuel–power cars, and central heating. All this is true and feeds the contradiction many activists feel.

However, a concept called "Just Transition," originating from labor movements and joined more recently by environmental and social justice groups, takes this contradiction into account, ensuring that while we stop the bad, we build an ever more detailed and realistic "new" to support communities in a transition off of fossil fuels. The frontline and movement support organizations that comprise the Climate Justice Alliance, in their analysis behind Just Transition Principles, call for us to "decolonize our imaginations" and "divorce ourselves

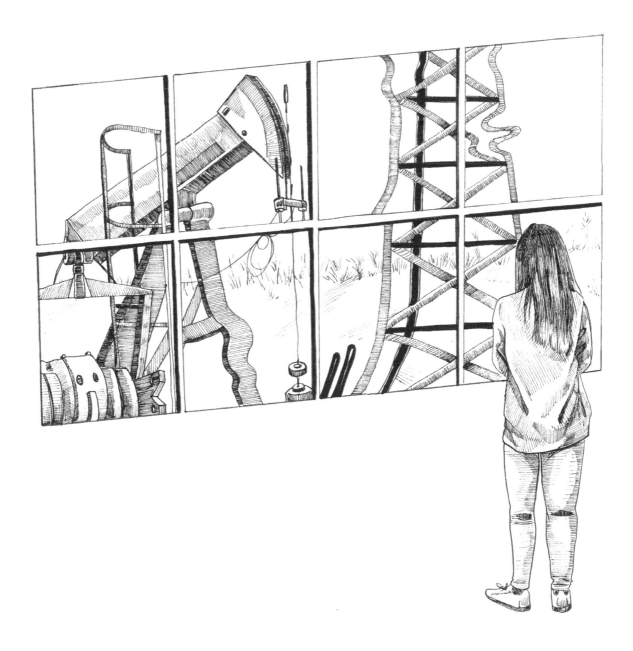

from the comforts of empire." The "comforts of empire" they acknowledge name the contradiction that has become a defining factor of modern life, and the call for "divorce" commits to a new vision for society and planet. This new vision is playing out in different ways across the globe via growing webs of small-scale agriculture, renewable micro-grids, and communities challenging the pervasive myth that "bigger is better." (Bigger to what end? Better for whom?) The Green New Deal is one potential avenue to protect people and planet together, chipping away at the myth that we need fossil fuels to support society.

However, we are now witnessing a final backlash of corporate greed beyond all reason, manifesting itself in the highest levels of government. All-out climate change deniers, as well as those who downplay the risks of climate change, have become the norm. (To name just two examples, funds for FEMA were diverted at the start of 2018's hurricane season to build more detention centers for asylum-seekers, and just a few months later a parking lot of private jets awaited world leaders who'd gathered to discuss climate change at the World Economic Forum in Davos.)

Instead of accepting this complacence toward fossil fuel "business as usual"—instead of despairing at the unending footage of people on rooftops, in mass shelters, digging through charred remains of homes—instead of despairing, I think about that day in the streets of Houston, shouting "shame" at Energy Transfer Partners. The windowed walls seemed to loom over us, projecting a feeling of authority, impenetrability, of secure systems and secrets behind. If we weren't certain then, today we know those buildings got just as flooded, just as deserted as their lights flickered and automatic locks shut off.

Perhaps one gift this accelerating gyre of emergencies has given us is vindication—the final lifting of the veil—just in case there was any lingering faith that authority still means something and can be depended on. Now we no longer need suspect. Benefit of the doubt is over. It's all a façade, a sham, a bully's bullhorn silencing a people's wisdom. So now we know. What we do with this knowledge is the key to the future.

This piece was submitted in collaboration with the Island Press Urban Resilience Project, with support from The Kresge Foundation and The JPB Foundation.

∾

Samantha Harvey *is a freelance writer, activist, and organizer of progressive philanthropy. A founding member of the Building Equity and Alignment for Impact initiative, she now supports grassroots climate justice and allied philanthropic organizations with ghost writing, narrative development, and group facilitation. New endeavors as a facilitator include working with white people to dismantle white supremacy. Samantha spent her early career as a modern dancer, traveling the world as a performer and teacher. She went on to earn a master's degree in environmental journalism at the University of Colorado Boulder. Her current writing can be found in* Orion Magazine, Dark Mountain, Earth Island Journal, *and more.*

Remembering the TERRAPODS
RANDALL AMSTER

It is one thing to try to restore a countryside, a watershed, even a lost species, all of which are tangible items that can be measured and replicated on some level with good data and appropriate technologies. But to truly understand a culture we must try to see the world through their eyes; for others to comprehend it, we must tell a compelling story. This project is of another magnitude: I am contemplating both physical and metaphysical components of the culture, necessitated by the complexities of the species at the heart of this cautionary tale. Undoubtedly, in order to comprehend the scope of the tragedy that unfolded, I will need to reconstruct a coherent and accessible aesthetic representation not only of the landscapes and the beings that lived within it but also of their hopes, dreams, and failings.

This prospectus is an attempt to outline for you, my benefactors, how I hope to proceed. The demise of this unique culture is an important subject of study that will have implications for our world as well. I have long wondered how people could inflict such a calamitous end upon themselves, and, while I believe my project can address the question of *how* this occurred, the deeper question of *why* remains elusive. An evolutionary rationale is not forthcoming for a species to be so willfully self-destructive, although, as you will see, the story is more complicated than it may appear.

In trying to understand what had become of these beings, which we are calling *Terrapods*, I initially had to decide how far back to go in creating a restoration model. Due to limitations of information, reasonable amounts of time spent on the project, and the massive scope of this endeavor, I concluded it will only be feasible to reconstruct a single moment in time to illustrate what has befallen this species.

Then I had to select which moment most fully depicts this species' brash ingenuity. Should I focus on the immediate aftermath of the cataclysm that engulfed them, complete with darkened skies and decimated environs? Should I highlight, instead, the time just before this, replete with its mundane activities and dissonant complacencies—even in the face of obviously mounting calamity? Or should I attempt to go back even further, potentially closer to the roots of the problem, when these clever but ultimately flawed creatures sowed the seeds of their destruction by imagining that the inexorable laws that bind everything in this universe somehow did not apply to them?

This species, like our own, knew that nothing lasts forever except eternity itself. They tended to imagine time as a progressive arrow pointing forward on an evolutionary scale rather than a medium in which reality unfurls as space expands into its domain. We, too, can scarcely grasp the large tapestry of individual and collective choices responsible for temporally ordering our pathways through the expanse; the forces and scales weaving this artistry remain beyond our genuine comprehension. Ultimately, everything loosed in the Great Unfolding catches up to us: all possibilities and outcomes came into being at the moment of the universe's inception. It remains for us to be the arbiters of how we experience and connect them.

This is all fine for philosophical reflection and discussion, but it does not answer my immediate question. Time may be immutable on a grand scale, but I am charged with recreating a microcosm of it and thus representing an entire civilization in the process. Perhaps these complex *Terrapods* simply made choices, either consciously or unconsciously, that led them down this

path toward ultimate immolation. Or perhaps it was a function of the stacked probabilities that defined their action-space and thus brought them to this denouement. Simply put, they may have been born into a paradigm where the majority of their choices led them here no matter what they did—or, less likely, they defied the odds of tenability by taking actions that specifically courted this outcome. No one can know for sure—even today, that knowledge lies beyond cognizance—and it may not matter.

I have my own suspicions about this, having studied the fragmented artifacts and lingering environs of their world for years, piecing together their modes of communication and conveyance from the puzzle of rare metal fabrications, toxic byproducts refusing to decay, and primitive digital recordings that survived. I believe they knew what was happening to them for a very long time before it actually transpired but chose to continue on that path regardless of the outcome. This was central to how they viewed themselves—namely, as intelligent but ultimately imperfect beings whose ability to acquire knowledge would enable their prosperity and would also be their undoing. While I cannot identify a specific moment when this ideology became paramount for them, it seems to permeate the entire era in which they became technologized.

As such, my inclination is to focus on the period immediately before the conflagration, in which the signs were abundantly apparent and the window of opportunity—assuming they could even have avoided the ultimate result—remained open for them to attempt to change paths. What I find most intriguing about this moment in particular is how skilled they had become in integrating a growing understanding of the problem with an equally robust capacity to avoid its implications. They would distract themselves from it, medicate themselves from feeling its effects, persecute those who attempted to bring it to their attention, and allow those directly impacted by it to be annihilated. I have studied many other species and never encountered a situation quite like this.

They had time to act, or at least try, but neglected to do so, as far as we can determine. By the time the worst effects really began to set in—the rampant toxification, the collapse of living systems, the decimation of populations, the runaway destabilization of their weather patterns— it was too late to do more than turn on one another in a desperate attempt to survive. What I do not fully understand is why those who seemed to have the means and power to do something about it chose not to and even (it appears) to actively block any meaningful change from occurring. Did they not realize that these forces would impact them as well? Did they have some conception of immunity as a function of their ingenuity that they thought would save them? There did seem to be a frantic search for other habitable worlds in their cosmic region, but surely they must have realized they were not at all biophysically suited or sufficiently advanced to actually get there. One can only wonder why they did not expend equivalent resources to meet their challenges at home.

Yet as I noted, this seems to be consistent with their patterns of willful ignorance and inevitable demise (whether internally or externally imposed). They were indeed highly intelligent and adaptable creatures in many ways, and I have come to admire their capacities for passion, humor, articulation, and love. Curiously, although their form is far removed from modern conceptions of beauty, I often find individual specimens oddly compelling as works of art. If I could gather them all on my private mantelpiece, I would do so. Instead, I am tasked with displaying them collectively for all to see—and limited to choosing but one moment from their time.

This, then, is my vision for the installation, attempting to capture both their mindset and lifestyles. The scene will be set against a backdrop of what they called "urban life"—a bustling display of combustion-driven vehicles, people ambulating with electronic devices in hand, the absence of animal or plant life in their midst other than a few specially curated species, a tapestry of concrete and metal structures. The look on their faces indicates a sense of purpose, a kind of inner longing, but an uncertainty as to what it is they are seeking. The noise around them is deafening, but none seem to hear it, instead opting for the relative quiet of their personal digital tethers to their invisible networks. Above them the sky is foreboding, below them the streets littered with refuse, and before them the air filled with particulate matter large enough to be quite nearly visible. This will be the background for my temporal restoration.

The foreground is still being determined, but I have a working concept I believe will serve to invite reflection on who these *Terrapods* were and how we might be more similar to them than we are inclined to acknowledge. The dominant image in this diorama will be a clock, a monstrous digital masterpiece that looms above the din, obvious yet invisible, unquestionably coordinating their activities in its subtle rhythmic progression. They are all aware on some level of what its presence implies—life is precious, the hour is late, pay attention, the time to take action is now—yet no one does more than casually glance up as their contrived personal pursuits draw them elsewhere. The visceral image of time literally ticking off in front of them connotes not a sense of urgency but of distraction; they mark its passage but somehow see it as an infinite commodity whose coffers will be replenished magically. The watchmaker is like a deity to them, yet they pay it almost no obeisance in their mundane affairs, ignoring its lessons at their peril.

Apparently they had gotten so good (at least in their terms) at fixing problems through their innate cleverness and rudimentary technologies that even until the final moment they must have suspected some novel innovation would save them. They had managed, it is true, to extend their individual lifespans. The records are of course quite garbled overall, but we can discern that toward the end they lurched frantically from one engineering fix to another, tampering with their atmosphere and scrambling for new energy sources. At every turn, however, they seemed to only make the crisis worse, which brings us back to the suggestion that effectively they had

courted their own demise. The window of time to change course stayed open for them longer than it rightfully should have, given their evident hubris and profligacy, but in the end even their admirable ingenuity couldn't save them from their unwillingness to make the shared sacrifices necessary to bring their lives into alignment with their world.

Dear colleagues, I have already gone on longer than anticipated with this update on my work here; please consider this as a prospectus for the current approval cycle, despite any shortcomings in its format or the somewhat unorthodox manner in which I have elaborated on my motivations and process. I hope this brief overview provides some context for my installation, testifying to the importance of the lessons from this species as they may impact our own practices and the larger search for meaning in which we are all invested. In short, I believe this project illuminates an important set of concepts to consider in our individuated contexts, as well as fundamental and widely applicable lessons. Capturing the essence of this intricate species, and of the particular moment in time I have isolated, continues to be challenging and rewarding all at once. After all, this dual sense of crisis and opportunity—of destruction and creation— reflects the way in which reality reverberates. If this project helps remind us of that and jolts our own tendencies toward complacency, then the time spent on remembering the legacy of the *Terrapods* will be worthwhile.

<center>❀</center>

Randall Amster, JD, PhD, is co-director and teaching professor of environmental studies at Georgetown University and is the author of books including Peace Ecology (Routledge, 2015).

What Hath God Rot?

John Bates

"Wrought": from the old English *geworht*—to work.
1 – worked into shape by artistry or effort, fashioned, molded
2 – ornamented, embellished, adorned, garlanded, illustrated
3 – consummated, finished, brought to pass, realized, perfected
4 – deeply stirred

"Rot": from the old English *rotian*—to rot
1 – to decay, spoil, putrefy, decompose
2 – to languish, deteriorate, atrophy, decline—a slow change from a state of soundness
3 – to become morally corrupt

❧

"Think of the starving Armenians."

My mother would say this whenever my brother and I would try to leave the table without cleaning our plate.

Our standard reply: "Okay. We'll box it up and send it to them."

Her standard reply: "It would rot and go to waste." Then, with a pointed nod toward our plates: "Eat."

And we would, stuffing in more meatloaf or peas or pork chops, grumbling about the damn Armenians. We didn't know, nor care, about their genocide in eastern Turkey where up to a million Armenians were murdered or died of starvation.

My mother, too, was likely served this admonition during her dinners. The Armenian cultural cleansing occurred during World War I, and she was born not long after, in 1924.

For her, and for us, it was one of many lessons around the concept of "waste."

❧

When I was young, my mother canned and froze various foods, as did my grandmothers, in the name of avoiding rot and waste. I was a child of the '50s, the generation after two world wars that bookended the Depression. My experiences of life and death were utterly unlike my parents' and grandparents' experiences. There was World War I; the flu pandemic in 1918, which killed 675,000 people in the U.S. (20 million worldwide); bank failures, massive unemployment and upheaval during the '20s and '30s; rationing during World War II in the '40s; and a polio epidemic in 1952 (58,000 cases).

Those were times of want, of fear, of constant uncertainty. Waste and rot were enemies.

"Waste not, want not," we were told, again and again.

Before those times, however, the early Euro-American settlers had a conflicted view on waste; this held true, in particular, regarding forests. Wood was both *in* the way and it *was* the way. Wood was incredibly valuable, entering into every walk of life. Wood built most buildings, bridges, wagons, railroad cars, fences; timber reinforced deep mine shafts and raised pedestrians above the mud on wooden sidewalks; it provided fuel for stoves, and made the steam that drove engines, sawmills, and factories; wood made heat for smelting

iron ore; and hemlock and oak bark produced tannic acid for tanning leather. Wood was also made into shingles—85 billion shingles were rived from white pine for the roofs of settlers' homes in a 24-year period in the Lake States, my home.

But wood was also in the way of farms that needed to be planted immediately. As Increase Lapham wrote in 1855, "It is much to be regretted that the very superabundance of trees in our state [Wisconsin] should destroy, in some degree, our veneration for them. They are looked upon as cucumbers of the land; and the question is not how they shall be preserved, but how they shall be destroyed."

A match helped to clear a forty, but fire was hard to contain. Historians estimate the amount of timber lost to fire ran as high as 20 percent of Michigan's original 380 billion

board feet of sawtimber. In Wisconsin, Filbert Roth speculated: "26 billion feet [of pine] was probably wasted, chiefly destroyed by fire," or, like Michigan, about 20 percent of the pine in the northern counties, but it may have been much more. Robert Fries conjectured in his book *Empire of Pine* that "perhaps more good pine timber was burned than ever reached the sawmills."

The Detroit *Post* (1881) saw the fires as lighting the way of civilization:

> Where the fires have raged, the forests have been killed. . . .
> There are square miles and whole townships where the earth is bare of everything. . . . The trees, the underbrush, and all the impediments to agriculture, it usually costs so much in toil for the pioneer to

remove, have been swept away, and the rich land lies open and ready cleared for the settler. . . .

Meanwhile, the lumber industry argued that same year that they had no choice but to cut the forests as fast as possible because of the danger of fire: "Pine must be cut speedily to save it from being destroyed by forest fires. It is a question whether this valuable timber shall be saved to be used for the convenience of human beings, or be wasted by destructive forest fires. If it is to be saved, it must be cut as fast as possible."

The plow was intended to follow the ax, the pastoral to replace the wild. The conversion of the Great Lakes forests from pine and sugar maple and hemlock to burned-over wastelands, and then to "weed" species like aspens, constituted "probably the largest human-caused forest type conversion in history." Between a fifth and a quarter of the forests of northern Wisconsin, Michigan, and Minnesota were converted to sun-loving aspen.

As for the settlers, they didn't see the destruction of so much valuable wood as wasteful—it was simply necessary.

All of this is to say that we European Americans have a complicated, if not at times twisted, relationship to waste.

༄

Waste is something perceived as unwanted. But it also means:
1 – to fail to use (something or someone) in an appropriate or effective way;
2 – to lay waste; to damage or destroy gradually.

༄

When I think about what we consider "waste" today, weeds come to mind. Susan Knight, an aquatic plant ecologist in northern Wisconsin, says a weed is simply a plant without a press agent. She should know. The names of a remarkable array of aquatic plants end in "weed"—pondweeds, pickerelweed, smartweed, duckweed, shoreweed. All of them perform valuable ecological functions, yet most lakeshore owners pull them and then later complain about the loss of fish or the erosion of their shorelines, oblivious to the ecological connections.

Weeds are also plants out of place, out of season or time, or too numerous. The "right" place, the "right" time, and the "right" number, of course, are vagaries of human perception. The carp is considered a "trash" fish in Wisconsin but gets eaten gladly in Asia; a tomato plant flourishing in the perennial flowers gets pulled; an eastern hemlock in a managed aspen forest must be removed; native understory species in industrial pine plantations receive herbicide.

Waste, then, depends on perception and need. After all, a plastic bottle headed for the landfill can become a cup for someone who is thirsty, or some rusting sheet metal can be treasured as a roof for one without a home.

༄

Listen to another view on waste: "It makes my heart hurt to see all those trees going to waste," said the head forester of Wisconsin's largest state forest. He was talking to me about his pleasure in fishing for big bass in Sylvania, a designated wilderness area in the Upper Peninsula of Michigan that supports some 15,000 acres of old-growth forest. The

old-growth trees he so devalued line Sylvania's many lakes, contributing to the pristine conditions that make those fish so big.

In his mind, old-growth trees have exceeded "economic maturity" and are "going to waste."

The state forester, with boards and cords as his mantra, couldn't see the many values of forests beyond the lumber. This utilitarian understanding of waste underpins much of the American ideas of progress and ingenuity.

Then there's rot, the precursor to what some determine to be waste. I made a quick list of things I want to see rot and some I don't want to see rot:

Good Rot!
- tin cans in the woods
- old boards that I can't burn
- our compost pile
- the leaves in my yard
- old shingles
- ripped clothes, bald tires, etc.
- other stuff that I throw away

Bad Rot!
- my car
- my house and roof
- food in my cupboards or refrigerator
- my watch, glasses, computer, jump drive . . .
- the vegetables in my garden
- my newer clothes, new tires, etc.
- other stuff that I still use

In the Oregon Cascades, I sit with my back against a massive Douglas fir tree in the Andrews Experimental Forest. Across the path is a western red cedar that's just as big—probably 20 feet around. Lying on the ground all around me are other giant logs covered head to toe in mosses and lichens, with lines of seedling trees sprouted on top of the logs, all cued up for their race to the canopy if one of these grandmother trees topples.

The definition between "live" and "dead" in trees is complex. Live cells within a conifer only comprise about 10 percent of the tree (leaves 3 percent, inner cambium 5 percent, and ray cells in the sapwood 2 percent). However, as much as 35 percent of the biomass of a dead tree may be comprised of live fungal cells. Thus, a decaying "dead" log may be biologically more "alive" than it was when living. Add in the millions of tiny arthropods and microscopic critters, all the mosses and lichens, and a whole city is happily at work in and on the logs.

This is where the rubber hits the road in ecology. It's difficult to wrap one's arms around what is rot and what is waste. Rot is happening all around me here, and, though this wood is decaying/rotting/going to waste, it's quite remarkable in its support of a rich cornucopia of life. I wish I knew how to distinguish each moss and lichen from the others, to give them the dignity of their names.

With their death transformed into so much life, I wonder if it's a pleasure for trees to know that when they die a community will appear. Surrounded by mosses, which are draped everywhere like Christmas tinsel, I see no waste here. This is the forest's version of a mausoleum—a "mossaleum," if you will—except there are no embalmed bodies. Quite the contrary. This is death robust with life. I'm reminded of how I pray every morning to be of greatest service. This prayer is surely answered for trees in their death, something I'd love to think could happen with my body when I die.

~

John Magnuson, an emeritus Wisconsin limnologist, has written about the "invisible present," the slow processes that we don't see happening because we're so busy twitching along in the immediacy of our lives. Other ecologists have written about the "invisible place," the spot where we are right now, but which we often know so little about. Surely, these rotting logs around me embody the complexity, the essence, of the invisible present and place. Two hundred years hence, they will have crumbled, disintegrated (or is it integrated?), creating a biological topography of long undulations in the landscape, often outlined by rows of even-aged trees now a century old and appearing to have been planted by a human with too linear a concept of forests.

Like slow cooking, this is slow rot. Can I foresee this process over centuries? More importantly, can I appreciate it? Can I revere it?

Before you stereotype me as just another tree hugger, let me say I appreciate roads, burn good firewood, have nailed thousands of board feet of wood siding and paneling, and have laid and varnished many hardwood floors. I write on paper and sell books printed on real paper.

So, I have no problem with using our utilitarian brains, like all people have since we started walking the land. However, we need to expand our concept of utility, and by doing so, redefine rot and waste. Perhaps, like slow food, we need a slow-rot movement.

So, to the final point: What hath God wrought/rot?

The definitions of rot and wrought appear to diverge, but I see the words as cleaving, in the two very different meanings of the word— to both split apart and to stick together. For something to have been "wrought" is for it to be fashioned, to be shaped with artistry, but it is also to consummate, to finish, to deeply stir. God (evolution, et al.) has fashioned, perfected, and adorned this world with astonishing life, all of which must, and will, perish and be consummated.

"To rot," from my vantage point next to these decomposing logs, is also a process of shaping, of finishing, of stirring. If I had been here when these trees fell, I would have mourned them, but only because, living in the invisible present, I wouldn't be able to see how this place was to be fashioned by the artistry to come. I would be blind to the deep stirring that was only just beginning. I would have felt too much loss to foresee how life and death would cleave together, to cause something new to become.

My carpenter brain reminds me that I could have made fine joists, excellent boards, and gorgeous flooring from these massive trees. When considering only those purposes, the trees have been wasted. For the purposes, however, of making possible a myriad of life forms, the trees have been utilized in a larger, slower endeavor, one that God (in all of her synonyms) would see as a transformation: a consummation—a finishing and a beginning.

And as for my mother, the starving Armenians, and the lesson on wasting food? I have learned to take only what I need.

~

John Bates *is the author of nine books and a contributor to seven others, all of which focus on the natural history of the Northwoods. He has worked as a naturalist in Wisconsin's Northwoods for 30 years, leading an array of trips and giving talks all designed to help people further understand the remarkable diversity and beauty of nature and our place within it. His most recent book is* Our Living Ancestors: The History and Ecology of Old-Growth Forests in Wisconsin (And Where to Find Them)*.*

One Generation's Treasure

David Solomon

Sometime in the 1860s, a ship of European settlers landed in North America, having conquered fear with the hope of a better life. Stowed somewhere among the knit fabrics, dishware, and hand tools was an innocuous culinary herb. Perhaps they intended to season fish with it, as many did in Britain, or perhaps they wanted to turn it into a sauce for roasted lamb. It would add a delicious hint of garlic flavor—something familiar to make a foreign land feel less foreign. We know this much. What we don't know is whether or not they salivated as they loaded it. We don't know if its deliciousness was worth taking up precious cargo space or if it was brought as an afterthought. They could have ended up with more room than expected and, like many of us do when preparing carry-on, packed to fill the empty space.

Regardless of intent, I'm left uprooting the consequences of their decision with my coworker, Katie, 157 years later. We walk methodically in a grid pattern among towering white oaks and tulip trees while carrying heavy bags stuffed full of garlic mustard—*Alliaria petiolata*—an invasive, non-native plant. Our motions become repetitive to the point of meditation. Step, bend, yank, stuff in bag, repeat. The palate of my ancestors is doing a number on my lower back.

The abundance of *Alliaria petiolata* at the eighty-eight-acre old-growth tract in the Hoosier National Forest known as Pioneer Mothers is overwhelming and disheartening. Each plant lives for only two years, but their impact, like any invasive's, isn't felt individually but collectively. As an allelopath, garlic mustard produces chemicals that alter soil composition. If it were just a single plant or even a few it wouldn't be so bad, but an infestation like this alters the soil chemistry enough to kill fungi that benefit the growth of native trees. It's the health of the trees in this virgin oak-hickory forest that I wish to protect.

Native herbaceous plants are also losing ground thanks to the dietary preferences of white-tailed deer. Unlike the European settlers, deer don't care much for the taste. Wafts of garlic aroma hit our noses as we toil away. I don't smell food, either. I smell the trash of history.

"What's the point?" asks Katie. "We're never going to eradicate it."

I know the feeling. You can't help but imagine the scale of the problem—weeds growing and expanding over hills and valleys and along riverbanks, shorelines, and cliff faces from sea to shining sea. Any biome you can think of has been infested by its own version of this national epidemic. Even with growing efforts to attack them, invasive weeds are continuing to spread on the boots of hikers, in the bowel movements of horses, on the bottoms of boats, and through nurseries that sell them.

Invasive plants have even infected our national culture. A tumbleweed on the desert plain is as American as—well, you can fill in the blank. And yet it isn't American at all. It's Russian thistle.

Even if we did eradicate garlic mustard from Pioneer Mothers, the impact would be negligible compared to the species' national reach. Viewed from this aerial perspective, my day spent pulling half a dozen bags' worth feels as inconsequential as turning off a light to save the climate.

"There are some places," I explain to Katie as I wipe the sweat from my brow, "that use an Early Detection Rapid Response tactic: they

focus on the new invaders and all but give up on the old, established ones, basically just trying to keep things from getting worse."

To keep up my own spirits as much as hers, I tell her about some success stories, like the twenty-seven invasive species, including some plants, that have been eradicated from the Galápagos and the 95 percent eradication of the yellow crazy ant from Johnston Atoll where the ants spit an acid that blinds migratory birds. Surely native plant and animal populations have been aided by these efforts. If nothing else, there are red-footed boobies who can see each other now that otherwise wouldn't.

I don't know if I'm justifying our work for Katie's sake or my own. The truth is, I'm not entirely sure how successful we are. Most of my career has been spent bouncing around the country for different seasonal jobs. I go to a national park or national forest and spray, pull, cut, and burn weeds for six months and then leave. I don't normally return the next season to see how or if the infestations have changed.

Once, when I worked at Gettysburg National Military Park, I asked a seven-year veteran of the place, Charlie, whether or not he had seen improvements in the invasive plant infestations.

"Not really," he said, "They've mostly just shifted around a bit."

I asked because, like anybody, I want to feel my work is useful and not just a chemical dump that fattens the pockets of herbicide companies. Add to that, peering past the falling horizon of my own future, I imagine my descendants trying to clean up my generation's residual

trash, including the glyphosate and triclopyr (chemicals I use to try to stem the tide of invasive plants) binding to the soil, working its way into all of us through our food and our food's food.

In this community of trash picker-uppers, we call friends and associates at other agencies for trade secrets. What tactics do they use on specific species? What works and what doesn't? We do test plots to experiment with new methods and monitor the results. It's like we're finding our way through the dark on hands and knees. It can take years to realize all you've been doing is shifting the infestations around. In one sense, a dim light comes on as you learn from your mistake, but, in another sense, you're still crawling through mud, so much still unknown.

At other jobs, I've maintained trails, clearing fallen trees and trimming overhanging branches or even building a new footbridge. The payoff is more obvious and immediate. You can see the worth of your labor in just one day as you hike out on a clear switchback or

make the inaugural crossing on a new bridge. If something is amiss, you see it right away—a loose board, a missed tree branch whacking you in the face, whatever.

We don't get that pleasure in invasive plant work. If we're applying herbicide, the only immediate discernible difference is the bluish tint the plants display from the marking dye we use to keep track of what we've sprayed. Returning in a week or so, you may see the leaves start to curl and yellow. Even if you do manage to pull or spray every garlic mustard plant in a population, you have to return again and again. The seed bank can last for five years. Given the distance of time and the slow march of incremental eradication, our level of progress, or lack thereof, is difficult to pin down. This is a long game. Patience and diligence are virtues, and so is the education and inspiration of those who will follow. Even permanent employees sometimes move away, making it imperative to pass on the lessons gleaned from trial and error while maintaining vigilant monitoring of any given plot.

There is a hopelessness in this line of work that isn't completely unfounded. The Burmese python population has exploded in the Everglades with no convincingly effective strategy to control it. Fourteen of the 38 native Hawaiian forest birds are now extinct due in large part to pathogens carried by introduced Asian songbirds. Kudzu, the vine that ate the South, smothers native plants and can even uproot entire trees while growing up to a foot a day.

This hopelessness can, like kudzu, consume us, too, if we focus on the unattainable goals of purity. Humans will never not have an impact. North America will never again resemble the land found by European settlers. We can, however, strive to mitigate our impact. We can find hope in the realistic: preventing new invaders while minimizing the spread of the old, narrowing our focus from every invader everywhere to the few right in front of us, such as garlic mustard at Pioneer Mothers.

There is always a gamble in the uncertain. Will my efforts matter in the long run? Will there be unintended consequences that trade one environmental problem for another? Will my descendants 157 years hence break their backs to clean up my mess?

The direction I choose to gamble is that to do something is better than to do nothing. I don't know if the rare and endangered species we are trying to protect will eventually go extinct due to stiff competition from invasive plants or for some other reason such as an inability to adapt to a changing climate. I don't even know for sure if garlic mustard will ever be eradicated from my pitifully small area. All I know is that regardless of what the next decade or century holds, I will be able to say I tried. We tried. We are trying. As I carefully ease the next weed from the moist soil, I—much like my European ancestors—visualize the future we could have instead of the future we fear.

∾

David Solomon has worked in invasive plant management for the past ten years. In 2009, he earned a degree in creative writing from Florida State University. He publishes a zine called Travel On about his time living and working in various states.

Cultivating Patience
Rebecca L. Vidra

Even after years of ecological training, I relish the mysteries of unfamiliar ecosystems. Somehow, not knowing the names of all the plants or discovering starfish clinging to underwater rocks allows me to more fully enjoy the surprises that nature provides. Recently, I moved far from my home in the Piedmont region of North Carolina to the temperate rainforests of tiny Cortes Island in British Columbia. As I hike through these forests, I find myself in stereotypical awe. The dense ferns, the towering firs, and the emerging mushrooms all astonish me, so different from the oak-hickory forests of home.

As a restoration ecologist, I am used to looking for signs of damage and subsequent repair—baby corals and sponges growing on scoured limestone rocks, willow trees colonizing eroded streambanks. Slowly, this rainforest begins to reveal scars of its own. Partially hidden by mats of mosses and huckleberry saplings, impossibly large stumps silently decompose. Accommodating hiking trails are all that remain of former logging roads.

This forest, which evokes such a spiritual response in me, turns out to be a recovering victim of clearcutting. Eighty years ago, most of the trees were felled, pushed out to sea, and barged to the nearest mill. Some were used to build the cozy cabins and main hall on the island. Inevitably, newly exposed soils washed off the land and into nearby Carrington Bay. Wildlife fled these sites, taking up residence in nearby forest patches.

But this forest is recovering. It is once again a diverse ecosystem, harboring cougars and wolves, chanterelle and oyster mushrooms. It didn't recover with the help of engineers or ecologists; nature recovered on her own.

Being a restoration ecologist is a good fit for me because patience is not one of my virtues nor is it a calling card for restoration projects. Restoration is essentially a process of healing. Instead, we like quick fixes: move the stream into a new channel with carefully calculated curves, glue the reef back together with concrete and epoxy, plant rows of hardwood saplings into the flooded field.

Aldo Leopold established one of the first restoration projects in this country back in the 1930s. Hoping to reclaim a diverse prairie from encroaching hardwood trees, Leopold and his Civilian Conservation Corps crew scoured the tiny, weedy strips of meadow along the railroad tracks for seeds. Because these areas were kept clear of trees as part of track maintenance, they harbored a diverse set of native prairie species. Grainy black and white photos of Curtis Prairie, named for the director of the Wisconsin Arboretum, feature triumphant CCC workers, leaning on their shovels and picks, implements of the mass destruction of the misplaced forest. Visiting Curtis Prairie today gives one a sense of not just how Midwest prairies used to stretch away into far distances but also of the work Leopold and his crew, and subsequent work crews, have put into creating this living relic.

Leopold's land ethic inspires restorationists as it has generations of conservationists. What strikes me about Leopold's story is his emphasis on human interaction with nature. Unlike John Muir, another icon of the environmental movement, Leopold wrote about the challenges of actively managing land. Foreshadowing current debates in conservation, his land ethic wasn't directly concerned with large preserves of wilderness but encouraged a thoughtful relationship between people and nature, a relationship that forms the foundation of restoration. He argued at the end of *A Sand County Almanac*:

We are remodeling the Alhambra with a steamshovel, and we are proud of our yardage. We shall hardly relinquish the shovel, which after all has many good points, but we are in need of gentler and more objective criteria for its successful use.

Over the past few decades, we have used our shovels to mitigate damage from development. The regulations make us impatient for measurable results. So, we spring forward with our plans, eagerly putting into place our own notions of how the recovery should look. We sometimes even give up on restoring a site and just start over from scratch, attempting to recreate an ecosystem with our limited technical skills and ecological knowledge.

In our rush, we bypass the early stages of natural healing, as when weedy pioneer species colonize a site and enrich the soil. As a result, restoration projects appear fake: orderly sites with smooth curves and just the right colors and spacing of plants. Something is missing—something magical, mysterious, and intrinsic.

As restoration has become a more widely accepted way of interacting with nature, serious criticisms have been raised. In 1982, philosopher Robert Elliot published a damning proposition saying that humans can never fully restore nature because restored sites are, essentially, fake nature. Even if these sites harbor the same set of species and perform the same ecological functions as pristine sites, there will be something missing. Elliot argues that the intrinsic value, or value in and of itself, can never be recreated by humans.

I recently asked my father, Andy Vidra, about Elliot's argument as we stood on the fifteenth hole of the Highland Park Golf Course in Cleveland, Ohio. We were standing on badly compacted bare earth, cracking underneath the sun of the summer sky. One lone maple seedling had pushed its way through the hard soil, but no other vegetation was present. A beautifully meandering stream trickled by our feet with symmetrical, sinuous curves. Polished stones were glued into the stream bottom and large root masses were held in place on the banks of the stream by netting and rebar. We were in the midst of a brand-new stream restoration project.

This new stream will likely protect the manicured greens from the eroding force of dirty flood waters and may even provide habitat for some aquatic organisms. The floodplain will eventually feature a selection of native wetland plants,

once the compacted soils are loosened and fertilized. "But," I asked my dad, "is this *nature*? Does this new stream have the same value as an undisturbed stream in a nearby forest?"

His sense was that it wasn't as natural as an undisturbed stream but that no such streams exist anymore in this highly urbanized landscape. And, it may not be perfect, "But it's a heck of a lot better than the old ditch," both in ecological and flood control terms. Yes, but will there be unexpected fish occupying the perfect ripples and unpredictable visits to the floodplain by warblers in the spring?

Maybe my children can return to this site in a dozen years and attempt to pry the glued rocks from the bottom to search for crayfish. But the indelible imprint of human beings—from the engineered stream channel to the graded floodplain—will take decades to fade. Much like invasive surgery, restoration can be a disturbance from which nature may take decades, or even centuries, to recover. We tend to rush past the rehabilitation and physical therapy right to a proclamation of remission. Can we instead cultivate patience, a confidence in nature's ability to heal herself through an almost magical, unknowable, and often messy recovery process?

Take a look at a forest five years after a big hurricane-caused blowdown. Thorny vines climb over small saplings and shrubs, creating a tangle of vegetation. Fallen trees still clog the site and a few lone seed trees may tower above the chaos, symbolic remnants of the former forest. For most of us, this scene is not pretty. Yet, if you listen, you will likely hear the rustlings of field mice, the call of birds, and the chirping of crickets. Through the early stages of succession, this forest is vibrantly healing itself.

It will take decades for this blowdown to resemble a mature forest: decades of weeds, decades of decomposition, maybe decades of further erosion and fragmentation from trails and surrounding roads. Eventually, in its own time, nature prevails. Despite its mysterious ability to heal itself, the forest may yet display scars of human intervention, and those may not fade in our lifetimes. The very act of healing, however, of growing through phases of weeds, young trees, and, finally, canopy closure, is valuable.

Now take a look at a newly "restored" wetland carefully carved into an abandoned tobacco field. You've hiked here through a soybean field and would have missed this site had it not been marked with caution tape and warning signs. Bright pink flagging tape marks the presence of hundreds of cypress saplings, many of them now dead sticks poking out of the mud at strange angles. The edge of the wetland is marked by the invasive and sharp-edged *Phragmites* grass. The sun beats down and you wonder how long it will take for the murky pools to evaporate, leaving the sculpted mounds of yellow clay high and dry.

It will take decades for this wetland to resemble a bottomland hardwood forest, decades of invasive grasses and vines clogging the growth of new trees. Decades of erosion and maybe even floods of water will reshape the engineered space into channels and pools.

We don't give this place decades to recover: we give it five to seven years. We have overplanted those cypress saplings, hundreds to an acre, hoping that at least enough survive until the project is given its label of success. We visit periodically to spray the invasive plants with pesticides and maybe to dig parts of the site a bit deeper, hoping water will stay long enough to turn the soil gray, evidence the site is becoming a wetland. And after a few years, we figure the site has been restored, it's in remission, and further check-ups aren't necessary.

And maybe they aren't. Maybe then it's time to let nature take over, to make this intruder into a functioning part of the landscape. It can function much like our bodies gradually accept a prosthetic limb, respecting its function but knowing it will never be fully integrated.

Our affinity for radical landscape surgery may be used to justify our continued march toward taming nature. Of course, we should not just wait around for nature to heal from our egregious assaults, and not all restoration projects are attempts to fake nature. Given the reality of climate change and our growing understanding of the important functions ecosystems provide, we should hone our tools of restoration and get to work. Pausing, though, we need to first consider whether our efforts are in support of a restoration industrial complex, eager to make money from fancy elective surgery instead of routine preventative medicine. Quite often, some action is needed to jump-start the natural recovery process, just like antibiotics are necessary to heal infected wounds. Certainly, Leopold's restoration site required the initial clearing of trees and the planting of key species to allow the biodiverse prairie to reclaim the site.

Let Curtis Prairie be a showcase for the slow recovery of which nature is capable. When planning restoration projects, let us honor and cherish the natural healing process, and let us foster patience for this patient. Old fields succeed into hardwood forests over decades. Old-growth forests take centuries to develop. Ecosystem dynamics are elaborate, complicated, and, in many cases, unknowable, much like our own healing process. Nature, when left in charge of its own destiny, may surprise us with the outcome.

~

Rebecca Vidra teaches at the intersection of restoration, ethics, and community at the Nicholas School of the Environment at Duke University. She directs the Duke Environmental Leadership Program and the DukeEngage in Kaua'i program, which brings students to the North Shore of the island for community-engaged restoration work. Her work is moving away from field-based restoration toward educational programming for wider audiences through the Nicholas School, but her three daughters still have to withstand her shrieks of glee upon finding yet another magical surprise on a nature walk, along the wrack line, or in the parking lot.

Whole Terrain Previous Volumes

Whole Terrain attracts writers widely recognized for their contributions to ecological literacy and environmental awareness, as well as promising new literary voices. Our talented student editors, chosen for each issue, uniquely and powerfully frame our themes. We also seek out reflections from Antioch University New England faculty and students. *Whole Terrain* is distributed to an extensive national network.

Breaking Bread
Volume 23 (Cherice Bock, Editor)
Everything and everyone eats; it's the cycle that connects us most thoroughly with the world around us. In this volume, authors and artists reflect on the implications of breaking bread, from the ritual of sharing a meal to the brokenness of our current food system, from the joys of eating food we participated in growing to the fascination of learning about the food cycles of other species. Featuring cover artist Betty LaDuke, poetry by Kim Stafford, and essays from nature writers such as Gary Paul Nabhan, scientists such as Joe Smith, and community organizers such as Sarah Nolan.

Trust
Volume 22 (Cherice Bock, Editor)
What does it mean to build a relationship of trust between human beings and other parts of the natural world? Authors and artists explore the concept of trusting other species, natural cycles, and signals from the natural world. A common thread also emerges regarding our own trustworthiness. Featuring work by Michael Branch, Allison Augustyn, Evan Pritchard, Tviga Vasilyeva, cover artist Jason deCaires Taylor, and others.

Metamorphosis
Volume 21 (Nat Morgan, Editor)
Metamorphosis is transformation, a significant change occurring over a period of time, forever altering a being, object, species, or community. Contributors to this issue of *Whole Terrain* explore various metamorphic processes from a variety of scales and perspectives, illuminating how we, as human beings, experience such transformations. Featuring John Calderazzo's poetry and essays by Kimberly Langmaid, Emily Monosson, and Gary Paul Nabhan, Metamorphosis sports two different cover images by artist Mariana Palova.

Heresy
Volume 20 (Michael Metivier, Coordinating Editor; Rochelle Gandour-Rood, Dan Kemp, and Brett Amy Thelen, Contributing Editors)
Insofar as we, as environmental professionals, share the same basic objective of promoting, maintaining, and protecting a healthy planet, how do we remain open to heretical ideas that

seem counterintuitive, but may ultimately prove beneficial? This volume encompasses contributions from noted scientists and environmental thinkers like Hasok Chang and Robert Michael Pyle, as well as accomplished multimedia practitioners such as playwright Kristina Wong and photographer J. Henry Fair.

Net Works
Volume 19 (Michael Metivier, Editor)
As environmental practitioners, we cast nets to sample nature, to gather knowledge, and to provoke action. Net Works collects the work of architects, poets, journalists, environmentalists, and economists who investigate this theme with foresight, rigor, and imagination. This volume includes pieces by Stephanie Kaza, Laird Christensen, Gregory McNamee, Philip Hoare, and a host of others.

Boundaries
Volume 18 (Martha Campagna and Dan Kemp, Editors)
In this volume contributors explore the boundaries between states, nations, cultures, species, and ecosystems, as well as those dividing the safe from the toxic, and reality from belief. Contributors include Bernd Heinrich, Alexandra Zissu, Michael Branch, Julie Zickefoose, Peter Marchand, and many others.

The Significance of Scale
Volume 17 (Rochelle Gandour and Vivian Kimball, Editors)
We grapple with questions on orders of magnitude both great and small. This volume presents perspectives on, and questions about, the significance of scale. Contributors include Kathleen Dean Moore, Jeffrey Hollender, Charles Siebert, Sandra Steingraber, John Calderazzo, and Seth Kantner.

((r)e)volution
Volume 16 (Peter Davenport, Editor)
This volume reflects on the link between evolution and revolution that we have defined as ((r)e)volution. Contributors include Lynn Margulis, Janisse Ray, Philip Camill, Donald Strauss, Jim Cummings, Briony Morrow-Cribbs, and Jonathan Merritt.

Where is Nature?
Volume 15 (Annie Jacobs, Editor)
As the human experience becomes more urbanized and technological, where do we find nature? Contributors include John Tallmadge, Mae Lee Sun, Michael Branch, Sheryl St. Germain, Freeman Dyson, and John Calderazzo.

Celebration and Ceremony
Volume 14 (Brett Amy Thelen, Editor)
Celebration and ceremony renew the human spirit and remind us of our connectedness to the divine, to the earth, and to one another. Contributors include Janisse Ray, Sheryl St. Germain, Margot Adler, Robin Kimmerer, Ron Steffens, Lisa Greber, Patricia Monaghan, and Tom Wessels.

Risk
Volume 13 (Alexandra Contosta, Editor)

Authors explore the nature of risk and offer innovative ways to evaluate its role in our lives and work. Contributors include Kathleen Dean Moore, Scott and Paul Slovic, Jerry Kier, Laird Christensen, Jon Jensen, Gregory Frux, Lorraine Mangione, and Thomas Webler.

Resilience
Volume 12 (Debra Mackey, Editor)

Reflections upon the resilience required to sustain ecological and social communities and the characteristics—dignity, wisdom, flexibility, courage, humility, and humor—which help make such resilience possible. Contributors include Alison Deming, Bernd Heinrich, John Tallmadge, Fred Taylor, Tim Otter, Willie Fontenot, and Ann Zwinger.

Gratitude and Greed
Volume 11 (Michael Wojtech, Editor)

An exploration of the dynamics of greed and gratitude as they relate to environmental practice. Contributors include Lewis Hyde, Robert Michael Pyle, Stephanie Kaza, Paul Krafel, Ethan Gilsdorf, Heidi Watts, April Newlin, Peter Temes, and John H. Van Ness.

Surplus and Scarcity
Volume 10 (Kristen Grubbs, Editor)

What does it mean to live a life of surplus amidst a world of scarcity, or a life of scarcity amidst the unfathomable worlds of surplus? Contributors include Thomas Moore, Michael Klare, Bruce Berger, Richard Fein, Tom Wessels, H. Meade Cadot, Beth Kaplin, Jonathan Atwood, Peter Palmiotto, Peggy Duffy, and Lanniko Lee.

Serious Play
Volume 9 (Susie Caldwell, Editor)

Play brings people together and sets the imagination in motion, both of which are integral to our ecological work. Contributors include Terry Tempest Williams, David James Duncan, Mitchell Thomashow, Joseph Meeker, David Sobel, Michael Branch, Andrea Olsen, Richard Grossinger, and Alan AtKisson.

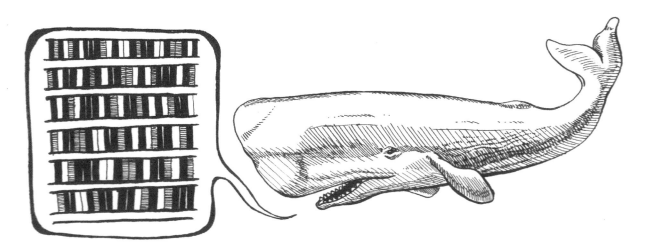

LEGACY AND POSTERITY
Volume 8 (Sherri Miles, Editor)
Writers reflect on the importance of environmental legacy in our lives and explore how a living legacy of caring is passed from one generation to the next. Contributors include Ann Zwinger, Nina Leopold Bradley, Simon Ortiz, Bruce Berger, Lee Stetson, Shigeyuki Okajima, Rabbi Everett Gendler, Maria Isabel Garcia, and Kaiulani Lee.

TRANSIENCE, PERMANENCE, AND COMMITMENT
Volume 7 (Sherri Miles, Editor)
In a world of movement and impermanence, how do we strengthen our commitment to the environment while changing our commitment to place? Contributors include Rick Bass, David Abram, Mitchell Thomashow, Chellis Glendinning, Jan Bailey, Dana Garrett, Alesia Maltz, Reyes Garcia, John Elder, A. d'Forrest Ketchin, and Elias Amidon.

CREATIVE COLLABORATIONS
Volume 6 (Martha Twombly, Editor)
A celebration of how disparate organizations, individuals, community groups, and businesses come to the table to solve tough environmental problems. Contributors include Gary Paul Nabhan, Frances Moore Lappé, Tatyana Mamonova, Kenneth Boulding, Paul Martin DuBois, David Dobbs, Richard Ober, Daniel Kemmis, and David Morris.

RESEARCH AS REAL WORK
Volume 5 (Amanda Gardner, Editor)
Environmental researchers invite the reader into passionate quests through their hearts, their minds, and their work. Contributors include Sue Holloway, Bruce Berger, Paul Spencer Sochaczewski, Deb Habib, Thomas Lowe Fleischner, Greg Gordon, Gene Logsdon, Dominick DellaSala, Dianne Dumanoski, and Paul Brooks.

EXPLORING ENVIRONMENTAL STEREOTYPES
Volume 4 (Sabine Hrechdakian and Ginger Dowling Miller, Editors)
Authors get to the heart of what divides us by analyzing the implications of stereotyping on perception, politics, diversity, and our relationship with nature. Contributors include Pattiann Rogers, bell hooks, Paul Shepard, Stephanie Kaza, Alexandra Dawson, Running Grass, Fred Rose, Betsy Hartmann, Thomas McGrath, and David Rothenberg.

ENVIRONMENTAL ETHICS AT WORK
Volume 3 (Jill Schwartz and Catriona Glazebrook, Editors)
An examination of the challenges and rewards of maintaining an environmental ethic and of confronting ethical dilemmas in the workplace. Contributors include Father Thomas Berry, David Brower, Steve Chase, Casey Ruud, Ruth Jacquot, Ty Minton, and Howard Nelson.

Spirituality, Identity, and Professional Choices
Volume 2 (Todd W. Schongalla, Editor)

Writers share personal stories about the connections between their professional lives, ecological identities, and spiritual beliefs. Contributors include David Rothenberg, Michael Caduto, Joy Ackerman, Cynthia Thomashow, Tom Wessels, and Ty Minton.

Environmental Identity and Professional Choices
Volume 1 (H. Emerson Blake, Editor)

Environmental professionals reflect on their own environmental practice and how they chose to make it their lives' work. Contributors include Mitchell Thomashow, Abram Bernstein, Alexandra Dawson, Shelley Berman, Fred Taylor, and John Carroll.

Back issues are available for purchase and may be ordered through the web at www.wholeterrain.com or via email at wholeterrain@antioch.edu.

ANTIOCH UNIVERSITY NEW ENGLAND provides transformative education through scholarship, innovation, and community action for a just and sustainable society. Master's degrees are offered in environmental studies, psychology, education, and management; and doctoral degrees in clinical psychology, marriage and family therapy, and environmental studies. Every program features an experiential learning component or practicum, so students can begin making a difference while they learn.

The Department of Environmental Studies is the oldest environmental studies graduate department in the United States, and has an extraordinary track record of creativity and leadership in the field. Master's and doctoral programs in the department emphasize a broad body of knowledge including science, policy, natural history, and ethics. Master's degrees may be earned in Resource Management and Conservation, or in Environmental Studies with concentrations in Advocacy for Social Justice and Sustainability, Conservation Biology, Environmental Education, Science Teacher Certification, Self-Designed Studies, or Sustainable Development and Climate Change. The doctoral program offers an interdisciplinary, research-oriented PhD.

To learn more about Antioch University New England, please visit us on the web at www.antiochne.edu.

ANTIOCH UNIVERSITY is a bold and enduring source of innovation in higher education. With roots dating back to 1852 and inspired by the work of pioneering educator Horace Mann, Antioch University was founded in 1964 on principles of rigorous liberal education, experiential learning and social engagement. The multi-campus university nurtures in its students the knowledge, skills and critical thinking to excel as lifelong learners, democratic leaders and global citizens who live lives of meaning and purpose.

More than 5,000 students across the United States and around the world are served by undergraduate, graduate and doctoral studies at Antioch University Los Angeles, Antioch University Midwest (Yellow Springs, OH), Antioch University Santa Barbara, Antioch University Seattle and Antioch University New England (Keene, NH) and the university-wide Antioch Education Abroad and PhD in Leadership and Change programs.

Together, students, alumni, faculty and staff form a visionary community that strikes a rare and essential balance between idealism and life experience. For more information about Antioch University, visit www.antioch.edu.